New Perspectives in American Art:

1983 Exxon National Exhibition

by Diane Waldman

This exhibition is sponsored by Exxon Corporation

The Solomon R. Guggenheim Museum, New York

Artists in
the Exhibition

Pegan Brooke

Bruce Cohen

Julie Cohen

Scott Davis

Steve Duane Dennie

Carol Hepper

Whit Ingram

Aaron Karp

Tom Lieber

Michael C. McMillen

Nic Nicosia

Published by
The Solomon R. Guggenheim Foundation, New York, 1983
ISBN: 0-89207-043-9
Library of Congress Catalog Card Number: 83-50248
© The Solomon R. Guggenheim Foundation, New York, 1983

Lenders to
the Exhibition

Leon and Evelyn Alschuler

Mr. and Mrs. Harry Anderson, Atherton,
California

Arnold and Porter

Mr. and Mrs. Matthew D. Ashe, Sausalito,
California

William Bartman, Los Angeles

Stephen Berg, Beverly Hills

Christine Bloomquist, Albany, California

Bonfilio/Wright, San Francisco

Avron and Sheila Brog, New York

Pegan Brooke

Sylvia Brown, San Francisco

Carol Burnett

James Butler, Los Angeles

Patsy Catlett, Albuquerque

Julie Cohen

Aviva and Carl Covitz

The Dannheisser Foundation

Scott Davis

Steve Duane Dennie

Louis J. Fox, Davis, California

Robert H. Halff, Beverly Hills

Carol Hepper

Dr. and Mrs. U.G. Hodgin, Jr., Albuquerque

Whit Ingram

Otis S. and Melinda O. Jones, Dallas

Aaron Karp

Robert and Maureen Kassel, New York

Tom Lieber

David M. Marcus, Los Angeles

Robert Nachshin and Monica Lipkin,
Los Angeles

Nic Nicosia

Harvey and Susie Phillips, Dallas

Marilyn and David Rhodes, New York

Mr. and Mrs. John G. Rogers, San Francisco

Toby and Sally K. Rosenblatt, San Francisco

Robert A. Rowan

Roselyne and Richard Swig, San Francisco

Mr. and Mrs. Carter P. Thacher

Rufus Williams, San Francisco

Earl Willis, New York

Werner and Mimi Wolfen

Roswell Museum and Art Center, New Mexico

Asher/Faure, Los Angeles

John Berggruen Gallery, San Francisco

Delahunty Gallery, Dallas and New York

Fuller Goldeen Gallery, San Francisco

Preface and Acknowledgements

Museum selections of contemporary art, whether on a national or an international level, continue to be as necessary as they are difficult and problematical. Necessary because without them the singling out of work of excellence from the vast volume of indifferent artistic production is slowed rather than accelerated; difficult and problematical because there are far more distinguished contributions in contemporary art than the agencies responsible for selection can accommodate or even acknowledge. While the methods that yield judgements by museums are less than scientific, the searching and evaluating process that precedes final selection in instances such as the current exhibition is nonetheless far from haphazard. In its initial stages it depends upon exhaustive slide viewings, then continues with the gathering of information from regional centers—through leads provided by colleagues, critics and artists whose judgements have been tested—and eventually involves the exhibition's curator in extensive travel across the continent. Ultimate conclusions are reached only after much soul-searching based on repeated visits to the studios of those who have emerged as finalists from an initially large field of candidates.

New Perspectives in American Art: 1983 Exxon National Exhibition thus is both an end and a beginning; for, as the selector's function concludes, a broader evaluation through criticism and public response follows quite inevitably, usually well beyond the exhibition's span. The longer this evaluation lasts and the longer the claims implicit in the choice remain a subject of discussion, the more defensible are the opinions of the selector and the greater are the merits as well as the satisfaction of the originating institution.

As for the present group, it consists of eleven artists of whom eight are men and three are women. Five are represented by painting, four by three-dimensional constructions and two by photographs. Five of the participants live and work in California, two each in Texas and New York, and one each in New Mexico and South Dakota. The stylistic spectrum encompasses as many idioms as there are artists. Paintings that recall the Neo-Plastic mode, expressionist abstractions and lyrical semi-abstractions would seem to refer to historical models from the time around World War I; surrealising constructions draw inspiration from the art of the era between the two world wars; gestural painting, fabricated photographic images and semiabstract photographs seem to be based on more recent models; other artists may turn to their environment or to precedents in ancient art. Range, media and modes are, in any case, as diverse as anyone who views the present artistic scene as pluralistic in nature could wish.

For so catholic a choice we are indebted to Diane Waldman, the exhibition's curator, and to those who have aided her and are listed in her own acknowledgements. The financing of *New Perspectives in American Art* was provided by Exxon Corporation, which has been consistently generous in its support. As in the previous exhibitions in the series, Exxon not only sponsored the show but also provided acquisition funds that assure that one work by each of the eleven artists chosen will enter the Guggenheim's collection. One of the purposes of the Exxon-sponsored national and international shows is encouragement of the artists selected, and both the exhibition and the accompanying purchases are effective instruments by which this objective is achieved. In addition, Exxon-supported acquisitions assume great importance for the Guggenheim Museum's collecting efforts, particularly when seen over the period of five years since the series sponsored by Exxon began. The Museum's indebtedness to Exxon Corporation is therefore very great indeed and Leonard Fleischer's personal advocacy as Senior Advisor to Exxon Corporation's Art Program is fully recognized and deeply appreciated.

Thomas M. Messer, Director
The Solomon R. Guggenheim Foundation

This exhibition would not have been possible without the support and cooperation of many individuals. I would particularly like to thank the staff members of the Guggenheim Museum for their diligent efforts on behalf of the exhibition and catalogue and to single out those who have been vital to the realization of the project. They are Susan Taylor, Curatorial Assistant, who has worked with me on all phases of the exhibition and catalogue; Carol Fuerstein, for her intelligent editing of the catalogue; her assistant, Shara Wasserman; Lisa Dennison, Assistant Curator; and Melissa Harris and Amada Cruz.

Among the numerous individuals who offered their insights and assistance, I would like especially to extend my gratitude to Judith Dunham, Maurice Tuchman and Stephanie Barron, Richard Koshalek and Julia Brown, Steven Nash and Sue Graze, Linda Cathcart and Marti Mayo, Jane Livingston and Clair List, George Neubert, Anne Kallenberg and Renee Kaplan. Sincere thanks are also due to the many gallery dealers who were extremely helpful. Among them are Betty Asher and Patty Faure, Diana Fuller and Dorothy Goldeen, John Berggruen, Hiram Butler, June Mattingly and Patsy Catlett.

Finally, I would like to express my appreciation to the eleven artists in the exhibition. It has been a pleasure working with them.

D. W.

New Perspectives in American Art

Diane Waldman

In the introduction to the catalogue accompanying the 1980 exhibition *British Art Now*, I wrote:

At a time when the visual arts are the subject of much controversy and seem less authoritative than they have been in the last few decades, it is refreshing indeed to witness a new vitality in British art today. The reasons for this resurgence are unclear—it is impelled perhaps by a handful of artists who feel the need for change. . . .

Like American art of the sixties, British art of the same period was large in scale, affirmative in feeling, pragmatic in its approach. The heroic gesture, the intimate touch strangely in keeping with the vast space of the canvases, the painterliness, texture, tactility and intense color, the anguish of the Abstract Expressionism of the fifties had given way to an optimistic, even materialistic view of the world and wholehearted acceptance of the very mixed blessing of pop culture and advanced technology. Painting and sculpture became monuments to the commonplace object; size for the sake of size, the industrial, the synthetic, the manufactured were embraced not only by many Pop artists but by color-field painters and Minimalists as well.

By the early seventies much sixties rhetoric began to sound hollow, the issues of the decade no longer seemed as clear as they had once been, the art appeared unfocused and lacking in vitality. There ensued a kind of stalemate in art which still exists and calls to mind the lull that occurred in New York in the late 1950s. That uninventive period of second generation Abstract Expressionists came to a close with the advent of Pop Art. The Pop artists brought with them a refreshing sense of change, a dynamism that sparked a whole series of new developments.

Whether the 1980s will usher in a similarly dazzling succession of new movements is open to question. An explosion of this sort does not seem about to occur in the States. . . .[1]

That explosion has not occurred; what has emerged in its stead is a movement loosely referred to as "The New Expressionism" that has come to dominate much contemporary artistic activity.

Neo-Expressionism has been largely identified with the art of three cities—New York, Berlin and Rome. Supporters of Neo-Expressionism have identified artists as diverse as Enzo Cucchi, Sandro Chia, Francesco Clemente, Georg Baselitz, Anselm Kiefer, A.R. Penck, Julian Schnabel, David Salle, Robert Longo, Keith Haring, among others, as significant interpreters of the new intellectual, cultural and moral climate of our time. Each of these cosmopolitan centers has provided an environment in which variations of this art form have flourished. New York, long a center of the very newest aesthetic concepts, has spawned its own creative phe-

nomenon in the form of graffiti art, a tough and genuine commentary upon today's society. In its most authentic state it is truly anarchical in spirit, an art of the streets and subways accessible, in different ways, to different levels of society and culture. For the most part, however, American Neo-Expressionism depends upon the media for its mythology and imagery, exploiting pulp, porn, comic books, commercials, gangster films for a tabloid view of American life. Unlike its European counterparts, American Neo-Expressionism is fundamentally formalist, less concerned with the social or political order and its interpretation than with the immediate visual impact of the image.

Although Neo-Expressionism has been applied as a generic term to artists of various nationalities, it is most appropriately used to designate developments in German art that have recently been brought to public attention. In contrast to the American phenomenon whose roots are in Pop culture, the sources for today's German expressionism lie in the generation of artists that preceded World War I. As Paul Vogt points out:

. . . one of the essential traits of Expressionism is its contradictions, its apparently chaotic multiplicity of divergent features, its contrasts between freedom and fettering, the individual and the masses, intellect and instinct, idealism and anarchy.

. . . German Expressionism is deeply stamped by the idea of a universal revolution, and not just one limited to the realm of aesthetics. The conviction of an urgent need to topple all values and relations is common to all its advocates, no matter what their individual views may be. Such conviction is the actual utopian goal of all Expressionist thinking and doing; and any means are justified for the revolution. The choice of means is in each instance determined by the ideological consciousness of the participating artists or groups.[2]

Even more importantly, as Vogt indicates:

. . . Expressionism has been a specific and familiar constant in German art for hundreds of years. Its essential features are deeply rooted in Germany's formal attitudes and specific ways of thinking. One must therefore regard this special view, order, and reading of the world as a national characteristic. Expressivity—as a synonym for an intense desire to utter, to communicate from the "universe of the interior"—is virtually representative of the uniqueness of German art; hence it logically characterizes the position of German art versus the Latin sense of form.[3]

Neo-Expressionist German painting has captured the style of its predecessor. References to Kirchner, Beckmann, Nolde and others abound in the jagged forms, acidic colors, controversial themes, strident voices of the newer work. Less

apparent, however, is the inner shriek, the compelling need to communicate from the "universe of the interior." But, just as New York has produced a mode peculiar to itself, Berlin, a torn and beleaguered city, has given rise to a form of art responsive to its own anguish.

Similarly, the work of the younger Italians has its specific cultural identity. In my introduction to the catalogue for the 1982 exhibition *Italian Art Now,* I singled out the "recovery of myth, the symbolic meaning . . . of fire and ritual, the organic harmony of art and of nature at its most elemental, the renewed preoccupation with alchemy as fundamental to even the sparest forms . . . in recent Italian art."[4] The heritage of Italy, embodied by Rome and its complex political, social and artistic history, has produced in the *Transavanguardia* yet another interpretation of Neo-Expressionism. Such diverse sources of inspiration as the social realism of the 1930s, the late paintings of de Chirico, the work of Savinio and de Pisis, the time-honored techniques of fresco, mosaic and bronze casting have been revived and translated into an idiom for the 1980s.

In an art world in transition, Neo-Expressionism has served to reopen a dialogue about painting, to question anew the very meaning of art. This dialogue is best served not by focusing on a single movement to the exclusion of other developments, but by an awareness of the pluralism that has marked recent art and continues into the 1980s. The energy and vitality so characteristic of the emerging art of the last few decades is still very much in evidence. The eleven artists in this exhibition testify to the ongoing spirit of experimentation, of change, of growth, that characterizes American art at its most promising.

As the *regioni* of Italy have produced unique artistic traditions, so many areas of this country, especially certain portions of the North, South and Midwest, have given rise to particular art forms. Painters as diverse as Max Ernst, Georgia O'Keeffe, Clyfford Still, Agnes Martin have been inspired by the special qualities of the regions in which they settled—the sense of an ancient or primitive presence, the nobility of the land, the vastness of space, the spirit of old cultures that have survived man's attempt to strip nature in the name of progress.

The landscape of South Dakota, remote, yet eerily beautiful, has left its mark on Carol Hepper, a native of the state. It has elicited from her an extraordinarily poetic response in the form of a body of work that unites respect for the past with a new means of expression. The folklore and myth of the past remain in South Dakota but the Sioux and the buffalo live in a land that is no longer theirs. The resulting sense of alienation and disruption is intensified by the seemingly endless, uninterrupted character of the land. Amidst surroundings so strange they seem almost surreal—variously recalling the paintings of Tanguy or the craters of the moon—Hepper creates her abstract sculpture. Her respect for the bleached land-

scape, the desiccated trees, the near-extinct penned-in buffalo is reflected in her choice of forms, colors and materials.

Hepper's sculptures are three-dimensional structures made from objects she has found at or near the buffalo ranch on the Indian reservation in McLaughlin where she lives and works. In her work she has incorporated bones, driftwood, animal hides without attempting to disguise their origin, alter their nature or aggrandize their inherent beauty as artifacts of a dying civilization. The animal bones (buffalo, cattle, deer), the hides (buffalo, calf, deer) she has tanned herself, the wood (either stripped or left with bark intact depending upon the type and weight and color of the hide she uses), the driftwood, retain a sense of their history. The toothmarks of the coyote and other scars on the animal skins, the weathering of bone and driftwood remind us of the previous existence of these things; but the sculptures are not meant to represent literally the folklore of the past they honor. Like David Nash and Michael Singer, Hepper is able to draw upon nature and upon earlier cultures to make a statement that is both timeless and contemporary.

As the work has grown in confidence, the artist has begun to experiment more freely with the nature of her organic materials, with variations of scale in sculptures that range from small and delicate to rugged and larger-than-life size, with qualities of tautness, transparency and translucency. As she has begun to rely less upon the history implicit in her materials and to extrapolate their inherent abstract forms, she has produced works that are luminous in their beauty and intense in their immediacy and poetic evocation.

Strikingly different from the sculptures of Carol Hepper are the works of Michael C. McMillen. In his drawings, paintings, constructions and installations—fragments of reality imbued at once with wry Dada humor and a feeling of desperation—he captures a sense of the transient nature of life. In certain respects McMillen's work recalls that of both Marcel Duchamp and Joseph Cornell. Relevant in this context are the element of chance, the love of play, the use of forms that trigger free associations, memories, reminiscences, the use of punning and double entendre. Although fantasy is central in the work of both Cornell and McMillen, that fantasy operates on different levels. In certain of Cornell's whimsical, lighthearted works of the 1940s toys, little silver spoons, seashells and crockery invoke an innocent, enchanted world of childhood, a genteel, Victorian atmosphere not encountered in McMillen's work. Moreover, the melancholy and withdrawal apparent in many of Cornell's constructions are absent from the more extroverted and worldly environments of McMillen. Whereas Cornell's work reveals a longing for the past, McMillen's is a pointed commentary on the present. Yet McMillen shares with Cornell a fascination with Hollywood; both have adapted film techniques in their work. For Cornell, however, the world of Hollywood was a fantastic invention of the

11

imagination, while for McMillen, who lives and works there, Los Angeles exists in reality, although that reality seems a bizarre fiction.

To a certain extent McMillen has been influenced by his experience in film-set construction. Yet the gigantic scale, the overblown fantasy, the apocalyptic vision of the medium has not found its way into his work. On the contrary, he often creates a world in miniature where tragedy and farce exist in precarious equilibrium. McMillen's work has been compared to Edward Kienholz's tableaux of the 1960s. However, Kienholz's explicit social commentary, shock effects, grotesque imagery and literal themes are fundamentally at odds with McMillen's subtler and more playful interpretations, where metaphor and realistic subject matter coexist. The shanties, garages, pool halls, ramshackle hotels and rundown tenements, littered hallways and deserted alleys he constructs represent the detritus of our civilization. Confronted with the wasteland he presents as reality, we must come to terms with pleasure, laughter, silence, isolation, pain, despair. But if McMillen presents a crumbling world, he also creates from this decay images of evocative poetry.

Many of the large-scale installations allow the viewer to enter a mise-en-scène. Here McMillen uses trompe l'oeil effects to create a heightened sense of reality at the same time he subverts that reality by presenting contradictory visual clues and changes in scale. The spectator, engulfed in this interplay, participates actively in the experience of the work. Indeed, McMillen heightens the experience by incorporating music, odors, textures—one is encouraged to touch the installation —and thus engaging all the senses. These large-scale works are accessible in the truest sense, for the viewer actually enters into them. Simpler constructions that present isolated fragments of a scene, such as *The Caledonia* (cat. no. 92), are, however, as provocative and affecting as the complicated installations.

The Zanzabar, 1982 (cat. no. 99), one of McMillen's most effective constructions, presents an abandoned dwelling, a relic of urban life. As in many of his other works, dust, decay, peeling wallpaper, rusting pipes, shattered glass convey a message about a dying order. But the exquisite craftsmanship, the subtle colors and skillful illusionism with which he brings his miniature world into being, remind us that McMillen is not only an astute observer of life but also an artist capable of distilling his perceptions into a rich and complex visual experience.

Pegan Brooke, Tom Lieber and Whit Ingram are all Bay Area artists. In the fifties the Bay Area was identified with a notable figurative school of painting that included Elmer Bischoff, Richard Diebenkorn and David Park. During the sixties and seventies both the area and the painters associated with it faded from prominence, as interest shifted to artists in Los Angeles and a rapid succession of new movements in New York established the hegemony of the East Coast. In the seven-

ties, art in the Bay Area, as elsewhere, was experimental, dominated by performance and video; now, in the eighties, painting is enjoying a resurgence, which is accompanied by a renewed interest in the figure and in the artists of the fifties.

Pegan Brooke describes her painting as:

. . . a life-long process of finding and exploring images which clarify and define my existence. I sense a basic longing everpresent in the human spirit which propels life's journey. It is this longing that draws us towards elements which are seductive and intriguing, as well as potentially dangerous and unknown; situations that may be as dense as a jungle (dark, passionate and obstructed), but in which pathways and clearings are occasionally revealed. Thus we continue.[5]

In her earlier paintings Paul Klee was a dominant influence. Like many artists of her generation, and indeed previous generations, she was attracted to the mystical qualities in the work of Klee, whose vision, rooted in northern romanticism and symbolism, offered an alternative to abstraction. But Brooke, whose mother was raised in Mexico, has traveled to Mexico and Latin America in her quest for fulfillment both as an artist and as an individual: here her encounter with Inca and Mayan sites proved the catalyst for change. The Mayan ruins in the Yucatan and the Inca city of Macchu Picchu have been important sources of inspiration: the architecture as well as the rich, dense vegetation, the intense heat and color have affected her deeply private, often metaphorical vocabulary of forms. Significantly, she now looks to American Romantic landscape painting rather than European tradition. Lately, the example of Marsden Hartley's obsessive landscape paintings have reinforced her desire to observe nature directly. The recent paintings and pastels continue to explore archaeological landscapes executed approximately two years ago; the most successful among these exude a new confidence and remarkable energy.

Common to all her work, which has evolved in the course of a short time, is a framing device—a window or a doorway—that guides the viewer into the interior of the painting. The earlier paintings were characterized by flatness and frontality, by subdued color and architectonic structure, and suggest the influence of Richard Diebenkorn. The newer work, on the other hand, is notable for its curvilinear forms, the incorporation of mysterious ladders, boats, exotic birds' heads, lush vegetation, tropical mountains and sea, space that is elliptical rather than planar, and color that radiates jungle heat. The ambiguity of the scenes depicted suggests that they are not intended to represent particular places, but that they serve a dual function: they evoke natural phenomena and also refer to the interior landscape of the self. Brooke's titles allude to such possibilities: *Bridge Over Blackness, Caught Between Paths, Caged, Conflicting Pathways, Ladders of Earth* (cat. no. 5), suggest a private mythology that does not easily lend itself to analysis.

One can identify references to the struggle between the elemental forces of nature, to nature and man, sex and birth and death, but to decode her vocabulary would be to destroy the deliberate ambiguity and compelling mythic quality that gives her work its energy and force.

Tom Lieber's painting, like Pegan Brooke's, has undergone a rapid transformation in the last few years. Admittedly influenced by Mark Rothko and by the late paintings of Philip Guston, Lieber's work is nevertheless intensely personal in feeling and expression. It is contemplative, subtle in configuration and color and powerfully emotive. Whereas Brooke uses nature as a point of departure for her expression of internal states, Lieber transcends the palpable world. In his search for archetypal forms that can convey universal meaning Lieber displays affinities with the artists of the New York School. Rothko denied that his mature paintings were pure abstractions and spoke of them as "portraits"; moreover, references to the figure and landscape can be read into them. Nevertheless, they can be considered entirely in terms of color, abstract form, volume and atmosphere. As Rothko intended, however, they also speak to us on a more profound level, as emblems of man's capacity to transcend the material and the empirical and attain a sublime, exalted state. Lieber gives new meaning to many of these same issues in his haunting, spectral images. Guston, an accomplished painter of lyrical abstractions, returned at the end of his life to the ideograms he had used in his paintings of the 1940s. Whereas his extremely graphic images have inspired many new-wave artists, his cuneiform characters and proficiency as a colorist have affected Lieber's own singular treatment of figure and field in his latest work.

The paintings that directly precede Lieber's most recent work bear the most obvious relationship to Rothko's canvases. In these, Lieber generally clusters a few wedges of color at the borders of an otherwise monolithic field. His luminous color, then as now, is both resonant and evanescent, lyrical and powerful. Had Lieber chosen to explore retinal perception, the abstract dynamics of color, he undoubtedly would have made an important contribution to Color-Field painting. However, his color and forms, like those of Rothko, function as vehicles to convey transcendental meaning. In the new paintings this expressivity takes on new, more compelling and more complex significance. In these works, Lieber has replaced the blocks of color with apparitional figures, which he has moved towards the center of the field. They are hallucinatory presences reminiscent of the ghostly forms that dominate Alberto Giacometti's paintings; like them, they are existential in meaning. These emblematic images transmit highly subjective feelings of isolation, anxiety, dread, guilt and anguish. They express Lieber's exploration of his own psyche and represent an aspiration to achieve the "tragic and timeless"[6] in his art.

The assemblages and drawings of Whit Ingram are as subjective as the

paintings of Tom Lieber, but their idiom is entirely different. The ephemera he incorporates into the assemblages—bits of driftwood, strands of wire, strips of cloth, photographs of sandpipers or seagulls—are delicate in color, tinted, bleached, stained or weathered. They reveal the artist's exquisite sensitivity to his surroundings and are transformed by him into a highly poetic, lyric statement. Like Cornell, Ingram gathers commonplace objects and alters them in a barely perceptible manner to create works of art of an intensely private nature.

Cornell's box constructions, including those he changed over an extended period of time, are self-enclosed and finite. Ingram's pieces, on the other hand, are directly affected by the space in which they exist. Although his works show a concern for process and site, they lack the public, declamatory qualities usually associated with environmental art, for their very fragile, whimsical and eccentric forms imbue them with a unique flavor. By virtue of Ingram's sparing use of materials and the extreme linearity of his forms, even the most three-dimensional pieces are like drawings in space.

In his ability to elicit from the most minute form, the most subtle and graceful mark, an imagery that is both refined and evocative, Ingram invites comparison with Cy Twombly. His marks, like Twombly's, seem random and sometimes depend upon the element of chance; usually, however, they are the result of careful deliberation. Because each line, fragment, detail and object, no matter how tiny, is so important in relation to the space it occupies, its shape, contour and juxtaposition with every other form is crucial. Moreover, like Twombly, Ingram favors irregular contours, subtle but luxurious color and incorporates references to nature within a basically abstract vocabulary. Indeed, the common thread that has linked Ingram's drawings and assemblages throughout his gradual evolution is the reconciliation of natural phenomena with abstract form.

The Dallas-based artists Steve Duane Dennie and Nic Nicosia share the medium of photography in common. Neither are interested in photography as a vehicle for social reportage but, like others working with the medium today, view it as an art form. Whereas Dennie's work reveals a lyrical aesthetic similar to that of Whit Ingram, Nicosia's *Domestic Dramas* recall the environments of Michael McMillen in their satirical wit and deliberate theatricality. Both Dennie and Nicosia make setups and photograph them but their approaches are very different. Dennie's constructions, composed of a few commonplace objects, are deceptively simple. In works of 1978-79 (cat. nos. 43, 44), he fictionalized nature by imposing a few scraps of colored papers onto various surfaces in a manner that appears somewhat random but in fact was as calculated as the procedures of painters of the most formal still-life compositions. His recent studio setups have featured more precisely delineated forms, sharper value contrasts, less explicit but more effective

painterly touches and even more ambiguous space than the earlier pieces. For his cut paper series, begun in 1979, Dennie constructed still lifes of paper, plastic, wood and string. By photographing these pieces on the floor he produced a distorted image, a distortion he enhanced by tinting the photographs sharp pink, yellow, orange, green, violet, blue and turquoise. In hand painting his black and white silver prints, he has created an art form that synthesizes painting and photography.

Dennie's trompe-l'oeil effects derive from the disjunction he creates between real and painted objects, perspectival and flat space, painting and photography. In his manipulation of elements he recalls the nineteenth-century painters William Harnett, John Peto and John Haberle, whose trompe-l'oeil still lifes were masterpieces of the genre. Yet in their complexity the images also bring to mind Marcel Duchamp's altered Readymades, models of artifice for Dennie's magical photographs.

While Dennie is chiefly concerned with establishing a dialogue between the real and the imaginary, Nicosia's *Domestic Dramas* are parodies of life as it is shown on the soaps, featured in ads, dramatized in films. The tableaux Nicosia constructs in his studio combine at least two levels of reality: real life (the actors, what they enact, certain props) and artifice (the painted representations of objects). He does not create spatial distortion with his camera but, rather, paints distorted perspectival illusions (in the floors, for example) and photographs them. In them we see Mr. and Mrs. Average American frozen in time, caught napping, showering, quarreling, trapped in their housedresses or their underwear, we witness suburbia unravelling before our eyes. But if the soaps, the movies and the ads portray anxiety, they also lead us to expect a happy ending. The conflict, confusion and chaos that reign in Nicosia's splintered, fragmented dramas make a mockery of that expectation.

Illustrations in children's books inspired his own early method of shorthand drawing. Similarly, Roy Lichtenstein arrived at his early cartoon style when he began to draw comic-strip characters for his sons. Indeed, parallels to Lichtenstein's work are evident in the younger artist's Pop style, genre subject-matter, satirical attitudes and in the careful construction of his tableaux. Moreover, Nicosia explicitly refers to Lichtenstein's work in his *Domestic Drama #2* (cat. no. 107) by incorporating one of that artist's fictional dramas into his own scenario.

Nicosia sets the stage for his *Domestic Dramas* with a number of carefully selected props—chairs, beds, floor lamps, television sets, desks, ladders, dressers. The objects are mundane, yet there is nothing ordinary about the way they are assembled. Nicosia fuses real objects and drawn images and manages to convince us that the scenes are plausible, both on the level of human existence and as art. Whereas Dennie's works are informed by a casual grace, the Cibachrome

photographs Nicosia makes are as organized as the sets, dramas and actors they record. Nicosia's exacting control is fundamental to the realization of his art, which shows us both the humor in our daily life and the drama that lurks just beneath its surface.

Bruce Cohen's paintings, like Nic Nicosia's dramas, are domestic in their subject matter. As his point of departure, Cohen uses commonplace objects or the environment: coats, slippers, shoes, pillows, stationery, vases, flowers, landscapes, sky. From ordinary reality he has wrested extraordinary visions: domestic interiors that border on the elegiac, the supernatural. Cohen shares with Pierre Roy the creation of a sense of mystery through the dislocation of objects in space, the illogical juxtaposition of spatial planes and the complex illusions of mirror reflections and trompe-l'oeil effects. Pierre Roy, who participated in the historic exhibition *Fantastic Art, Dada, Surrealism* mounted by Alfred H. Barr, Jr. at The Museum of Modern Art in 1936, juxtaposed symbolically meaningful objects in paintings that suggest intriguing affinities to Cohen's poetic and poignant fantasies of the commonplace. Some of David Hockney's paintings also have a bearing on Cohen's work. In Hockney's memorable *Mt. Fuji* of 1972, for example, the use of reflections and the singular placement of a flower, which functions both as a meaningful form and as a device to telescope near and far distance, find parallels in Cohen's recent paintings.

Yet it is not the choice of subjects, nor their fastidious rendition, nor the merging of near and far distances, important though these may be, that constitutes Cohen's most telling contribution. Rather, the heightened sense of the object as icon and the portrait he paints of the world are most significant here. His compelling vision of domesticity simultaneously reveals to us with heightened immediacy the beauty of everyday life and a glimpse of the mysteries that lie beyond it, hidden to our perception.

The convergence of near and distant space and the transfiguration of the prosaic into the sublime in Cohen's work recalls, above all other art, the painting of the Early Renaissance. His presentation of the space, the world, as exemplified in Jan van Eyck's *Giovanni Arnolfini and His Bride* of 1434, affirms that the modern artist is able to express the duality of existence, the mundane and the spirtual in contemporary terms.

The austere and reserved paintings and drawings of Scott Davis reveal certain affinities with the art of Bruce Cohen. For like many artists who work in what appears to be a pure, geometric abstract style, Davis alludes to an order of existence that encompasses the real and the imagined, the concrete and the illusory. Like Mondrian before him, Davis seeks to express exaltation through reduced forms and colors. Titles such as *Eleusinian Mysteries* (cat. nos. 33-36) offer clues

to the many layers of meaning at the heart of his paintings. Despite these parallels with Mondrian it was the inspiration of Duchamp that was decisive in Davis's development. The influence of Duchamp is apparent in the chance effects of the earliest work and in certain recent paintings and drawings where ironic detachment or a sense of play is involved. However, most important for Davis has been Duchamp's cerebral attitude toward art and his veiled and complex imagery.

As Davis pared down his means, he reduced his colors drastically, often using a white field with black or green shapes. The minimal palette notwithstanding, there is coloristic and textural complexity: underpainting in various colors enhances black or green forms; where figure and field meet, the buildup of paint energizes edges. In the interim between the execution of these reduced canvases and his most recent work, Davis executed a monumental-scale painting, *Annunciation* of 1982, inspired by Renaissance depictions of the same subject. Although Davis's painting is fundamentally abstract, the sense of a miraculous event is evoked through movement from left to right, through the stillness suggested by color, form and line. Davis has looked to other Renaissance paintings, such as Giovanni Bellini's *St. Francis in Ecstasy,* ca. 1485, for inspiration for his pure abstractions.

Most recently, the experience of working on a mural called *Thinking and Working* has stimulated Davis to experiment with a wider range of color in a series of the same title. Here he uses primaries and a grayish umber with accents of black and red. He has created greater luminosity and a more varied visual field in which his forms can interact. At the same time, he has opened up the expanse of the field, both laterally and in depth, in a progression that may be compared to the evolution from the closed, hermetic space of medieval art to the larger arena of Renaissance pictorial space.

Like Bruce Cohen, Davis distills both his experiences of the real world and the perceptions that allow him to surpass that world. While he does not deny the validity of representational imagery, for him the magic of painting depends on the mystery of abstraction. Only by transcending the reality around him can Davis capture the enigma of abstract form.

Aaron Karp, like Scott Davis, has been considered a painter of pure abstraction. He says of his work:

The notion of music as interval, as something that occurs in time . . . has a great deal to do with my work. The paintings are about rhythm, about harmony and dissonance. They are about music inasmuch as music can become something that one can experience with the eyes. The paintings are about color. The paintings are about line. The paintings are about movement[7]

He maintains that his paintings are about the effects color conveys when it is woven together. In them tape functions as line, edge and form and is used to build up as few as four or as many as fourteen layers of color. For the artist, "The end result of this extended process is a surface that becomes a physical landscape, a topographical map of the painting's development."[8]

In the course of the last several years, Karp has progressed from emblematic or heraldic imagery in a figure-ground relationship to virtual abstraction and most recently, toward a semblance of figuration integrated into a flat field. The controlled abandon, the centralized diagrammatic shapes, the soft pastel color of the works of the last few years have recently given way to a freer emotional expression, a broader range of forms and a richer, more intense and varied palette. Throughout this evolution, the paintings have reflected the artist's continuing concern with reconciling the seemingly contradictory elements of a rigidly structured grid system and expressionist brushstrokes.

If the early paintings reflect Karp's longstanding admiration for Monet, the newest reveal the influence of the Italian Futurists. Karp's dazzling color is now enhanced by compelling sequences of forms in motion. As the forms have become freer, they have begun to pulsate, to move with ever greater speed. Shapes evoke undefined movement and suggest but do not clearly describe figurative forms, a parallel veiling of meaning that is provocative and tantalizing. As in the earlier canvases, gestural brushstrokes, straight-edged ribbons of color and shifting diagonals create the impression of forms and colors simultaneously holding the plane and weaving in and out of space.

The grid structure, which dominates the earlier paintings and appears in fragmented form in the recent canvases, is totally subverted in a series of oil pastels begun this year. The fragile and elusive lyricism of the previous work has given way to an explosion of energy, a newly liberated whiplash line, hothouse color, primal form. The luxuriant density and inherent lavishness of oil pastel appear to have induced the artist to forego, at least temporarily, the relative restraint that characterizes the larger body of his work, which is executed in the very different medium of acrylics.

Karp's process, which he describes as "revealing and concealing," has in the past produced canvases and works on paper that mediate between systematic imagery, painterly process and vibrant optical effects. A body of work has resulted that is active, resonant with color and motion and yet demanding of a prolonged reading. His paintings function on the level of pure perceptual phenomena—as statements about color, line, movement—and as complex and inventive commentaries about the visual stimuli generated by the worlds of nature and art.

Like Michael McMillen, Julie Cohen builds miniature worlds. Much as Kurt Schwitters spoke to us of his own time through the universe of his work, Cohen comments on her era in her unpeopled sculptures. In her anthology of artists who have left their mark on her development, Cohen has cited painters and sculptors as diverse as Rothko, Klee, Monet, Cézanne, Noland (for color), Michelangelo, Ingres, Raphael, Degas (line), Matisse, González, Brancusi, Robert Morris, Michael Singer, Eva Hesse (form), among others. She also refers to the influence of her architect father, with whom she visited construction and renovation sites. Her art is drawn from the past, from the ruins of ancient Rome, the splendors of Florentine architecture, the harmony and order of Michelangelo's Laurentian library and nurtured as well by contemporary painting and sculpture. Cohen's sculpture is as condensed and meaningful a distillation of her culture as Hepper's is of her own milieu.

Whereas the earlier work was characterized by contained, often whitewashed rectilinear forms and architectonic order, as her style has developed over the last few years, Cohen has begun to use more irregular contours, organic shapes and intense painterly effects. One wall construction of 1981 (cat. no. 23) recalls both Mondrian and Cornell in the austerity of its construction and the purity of its form. Yet other, more recent works (cat. nos. 27, 29) resemble both the constructions of Schwitters and the early Surrealist boxes of Louise Nevelson in their formal qualities, although they lack the irony, verbal and visual punning, literary meaning and Freudian implications of Dada and Surrealism.

Cohen fashions her magical, private cosmologies from ordinary materials, odds and ends of wood she nails and glues together. Surfaces are worked or left raw, without any attempt to disguise their common origins. She makes her surfaces come alive by leaving visible the traces of her brush or the nails that hold fragments together. Her muted palette of blues, silvers and rose colors emits soft light that adds a poetic dimension to the constructions. Small and delicate, they nonetheless emanate a strength that derives from the rightness of the relationship of interior units to exterior dimensions. Although most of the constructions are wall related, Cohen has executed several freestanding pieces, the most successful of which (cat. no. 28) recalls Brancusi and synthesizes an irregularly shaped circular form with a base of two-by-fours held together with wire. Common to all but the sparest examples is a feeling for nuance, a provocative juxtaposition of open and closed forms, an exquisitely lyrical range of color. Cohen's constructions are poetic visions that encapsulate perceptions of past and present. Resonant with a presence that belies their very small size, they offer us a universe where fantasy and reality coexist.

The eleven artists singled out here do not represent an identifiable move-ment or school. Rather, they are highly individualistic in their forms of expression. They share, however, a vitality, a positive attitude, an adventurousness, a willing-ness to examine the art of their precursors and use its lessons to nourish their own work. Together, they offer us perspectives on the art that is emerging in the United States today.

Footnotes

1. Diane Waldman, *British Art Now: An American Perspective, 1980 Exxon Inter-national Exhibition,* exh. cat., The Solomon R. Guggenheim Museum, New York, 1979, p. 9.

2. Paul Vogt, "Introduction," *Expressionism—A German Intuition, 1905-1920,* exh. cat., The Solomon R. Guggenheim Museum, New York, 1980, p. 16.

3. Ibid., pp. 16-17.

4. Diane Waldman, *Italian Art Now: An American Perspective, 1982 Exxon Inter-national Exhibition,* exh. cat., The Solomon R. Guggenheim Museum, New York, 1982, p. 8.

5. Pegan Brooke [statement] in *Emerging Northern California Artists,* brochure, Orange County Center for Contemporary Art, Santa Ana, 1982.

6. Marcus Rothko and Adolph Gottlieb with unacknowledged collaboration of Barnett Newman [letter] in Edward Alden Jewell, "The Realm of Art: A New Platform and Other Matters: 'Globalism' Pops into View," *The New York Times,* June 13, 1943, p. x9.

7. Aaron Karp [statement] in *Quarterly Bulletin,* Roswell Museum and Art Center, vol. 30, Spring-Summer 1982.

8. Ibid.

Pegan Brooke

Born in Orange, California, July 19, 1950

Extensive travel in Mexico, Central and South America, 1966-present

University of California, San Diego, B.A., 1972

Drake University, Des Moines, B.F.A., 1976

University of Iowa, Iowa City, M.A., 1977

Stanford University, California, M.F.A., 1980

Visiting Artist/Lecturer, University of California, Berkeley, 1982

Instructor, Sonoma State University, Rohnert Park, California, 1983

Lives and works in Oakland, California

Selected Group Exhibitions

Joslyn Art Museum, Omaha, *The Chosen Object,* April 23-June 5, 1977. Catalogue with text by Ruth H. Cloudman

Springfield Art Museum, Missouri, *Watercolor U.S.A.,* April 24-June 19, 1977. Catalogue with text by William C. Landwehr

Des Moines Art Center, *29th Iowa Annual,* May 29-July 14, 1977. Catalogue with text by James T. Demetrion

University of Iowa Art Museum, Alumni Center, Iowa City, *Painterly Environments,* 1977

University of Nebraska Art Museum, Omaha, *Second Regional Invitational Exhibition: Eight Middle West Painters,* February 27-March 17, 1978

Des Moines Art Center, *30th Iowa Annual,* May 14-June 14, 1978. Catalogue with text by James T. Demetrion

Cedar Rapids Art Center, Iowa, *Cedar Rapids Art Center Annual Exhibition,* 1978

Suzanne Brown Gallery, Scottsdale, Arizona, *Women on Art,* January 21-February 4, 1981. Catalogue with texts by Erma Bombeck and Suzanne Brown

Chautauqua Art Association Galleries, Chautauqua Institution, Chautauqua, New York, *24th Annual Chautauqua National Exhibition of American Art,* June 19-July 12, 1981. Catalogue with texts by Millie Giles and Nancy Hoffman

San Jose Institute of Contemporary Arts, California, *Beyond Words,* June 30-July 31, 1981

University of Houston, *The Image of the House in Contemporary Art,* November 8-December 4, 1981. Catalogue with texts by Charmaine Locke and William Simon

California State Hayward University, Hayward, *Bay Area Paintings,* November 13-December 11, 1981

Suzanne Brown Gallery, Scottsdale, Arizona, *New West Talent,* November 19, 1981-January 2, 1982. Catalogue with text by James K. Ballinger

Hayward Forum for the Arts, Hayward, California, *21st Annual Bay Area Arts,* May 20-23, 1982

Moscone Center, San Francisco, *50th Annual San Francisco Arts Commission Exhibition,* June 25-27, 1982

Orange County Center for Contemporary Art, Santa Ana, California, *Emerging Northern California Artists,* August 6-27, 1982. Catalogue with text by Cay Lang

Chevron USA Corporate Galleries, San Francisco, *Tropical Visions by California Artists,* May 27-June 30, 1983. Catalogue with text by Suzaan Boettger

Selected One-Woman Exhibitions

Eve Drewlowe Gallery, University of Iowa, Iowa City, *Pegan Brooke—Horse: An Offering,* November 21-29, 1977

Jan Shotwell Gallery, Des Moines, *Pegan Brooke: All Life is Rhythm—Pictures,* April 17-29, 1978

Stanford University, California, *Pegan Brooke: Paintings and Drawings—MFA Exhibition,* May 13-29, 1980

Hansen Fuller Goldeen Gallery, San Francisco, *Pegan Brooke: Paintings and Drawings,* May 26-June 27, 1981

Fuller Goldeen Gallery, San Francisco, *Pegan Brooke: Paintings and Drawings,* February 8-March 5, 1983

Scottsdale Center for the Arts, Arizona, *Pegan Brooke: Paintings and Drawings,* April 29-June 12, 1983

Selected Bibliography

Nick Baldwin, "Brooke's Rhythm," *Des Moines Sunday Register,* April 23, 1978, p. 5 B

Carol Donnel-Kotrozo, "Women and Art," *ARTS Magazine,* vol. 55, February 1981, p. 11

Andree Marechal-Workman, "Bruce Beasley: New York," *Artweek,* vol. 12, June 20, 1981, p. 6

Alan Temko, *San Francisco Chronicle,* June 20, 1981, p. 36

Suzaan Boettger, "Fresh Paint, New Fingerprints," *San Francisco Chronicle,* June 27, 1982, pp. 15-16

Robert Ewing, "A Group's Allurement," *Artweek,* vol. 13, August 14, 1982, p. 6

Christopher Brown and Judith Dunham, *New Bay Area Painting and Sculpture,* San Francisco, 1982, pp. 9, 67

Thomas Albright, *San Francisco Chronicle,* February 19, 1983, p. 38

Andree Marechal-Workman, "A Logic of Conflict," *Artweek,* vol. 14, February 26, 1983, p. 6

Suzaan Boettger, "Mayan Landscapes," *San Francisco Focus Magazine,* vol. 30, February 1983, p. 37

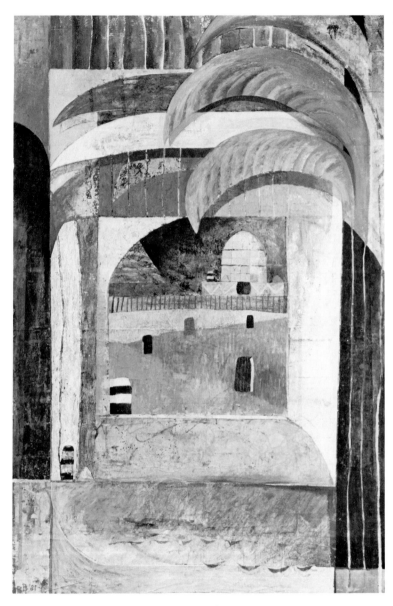

1.
Tikal Twilight. 1981
Acrylic and mixed media on canvas, 96 x 54"
Courtesy of the artist and Fuller Goldeen
Gallery, San Francisco

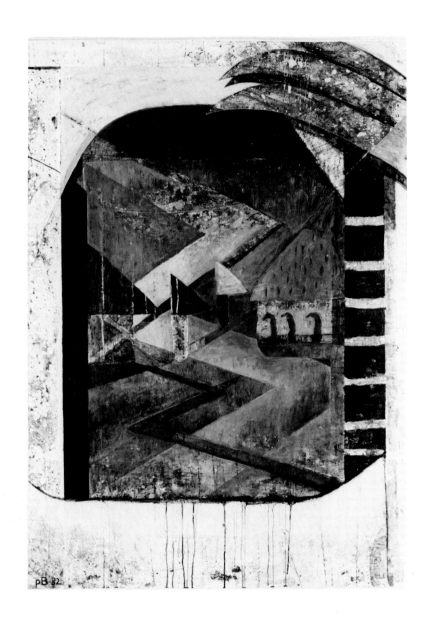

2.
Red Path. 1982
Acrylic and mixed media on canvas, 73 x 52″
Courtesy of the artist and Fuller Goldeen
Gallery, San Francisco

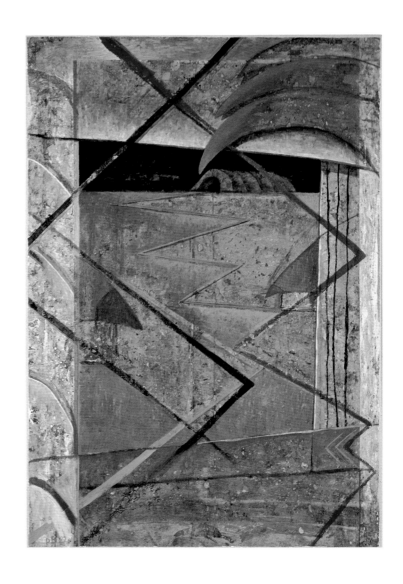

3.
Animal Paths. 1982
Acrylic and mixed media on canvas, 80 x 57″
Courtesy of the artist and Fuller Goldeen
Gallery, San Francisco

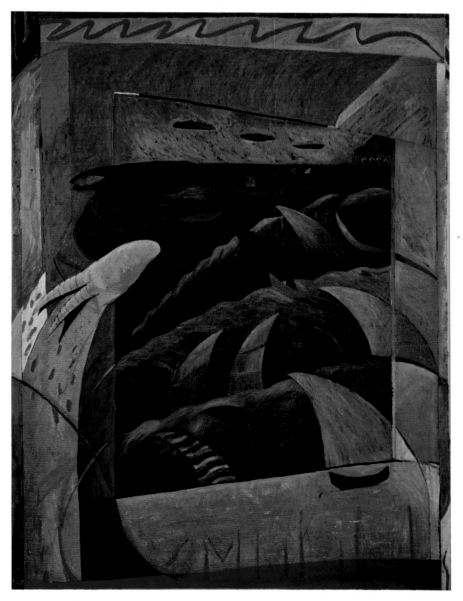

4.
Big Sea. 1982
Acrylic and mixed media on canvas, 97 x 77"
Collection Louis J. Fox, Davis, California;
courtesy Fuller Goldeen Gallery, San Francisco

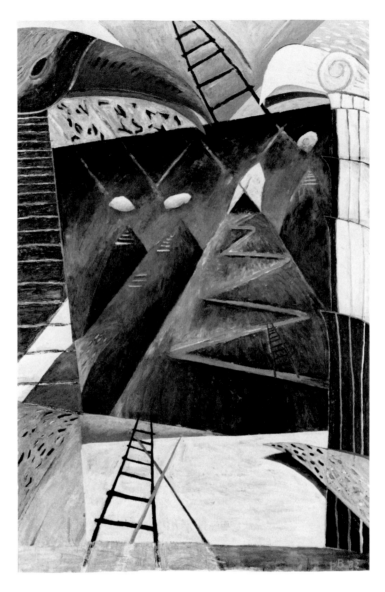

5.
Ladders of Earth. 1982
Acrylic and mixed media on canvas, 77 x 51″
Courtesy of the artist and Fuller Goldeen
Gallery, San Francisco

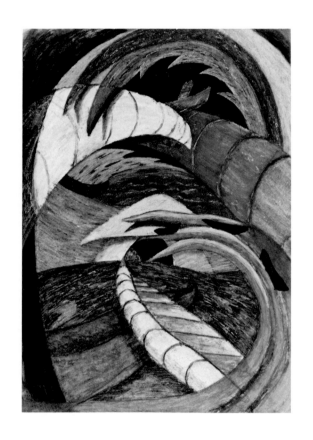

6.
Flood. 1982
Oil pastel on paper, 32 x 23"

Collection Mr. and Mrs. Harry W. Anderson,
Atherton, California; courtesy Fuller Goldeen
Gallery, San Francisco

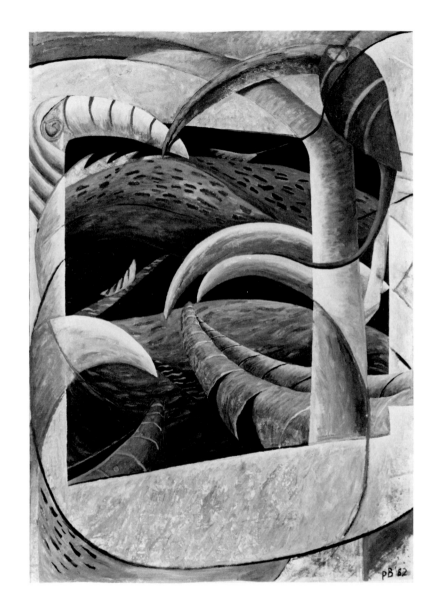

7.
The Flood. 1982
Acrylic and mixed media on canvas, 72 x 52″
Collection Mr. and Mrs. Carter P. Thacher;
courtesy Fuller Goldeen Gallery,
San Francisco

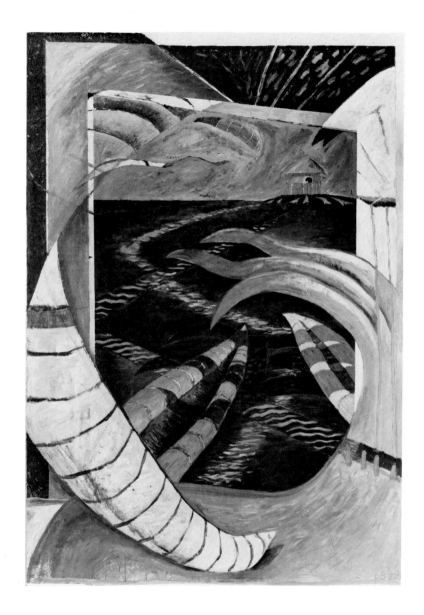

8.
Reed Boats. 1982
Acrylic and mixed media on canvas, 75 x 53"

Collection Wright/Bonfilio, San Francisco;
courtesy Fuller Goldeen Gallery, San
Francisco

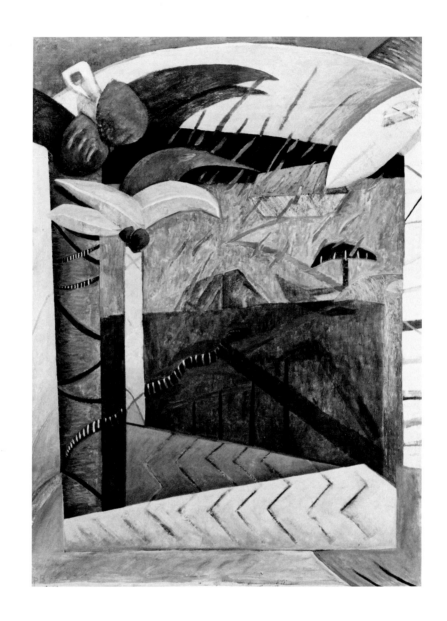

9.
Chac (Red Rain). 1982
Acrylic and mixed media on canvas, 79 x 58"
Courtesy of the artist and Fuller Goldeen
Gallery, San Francisco

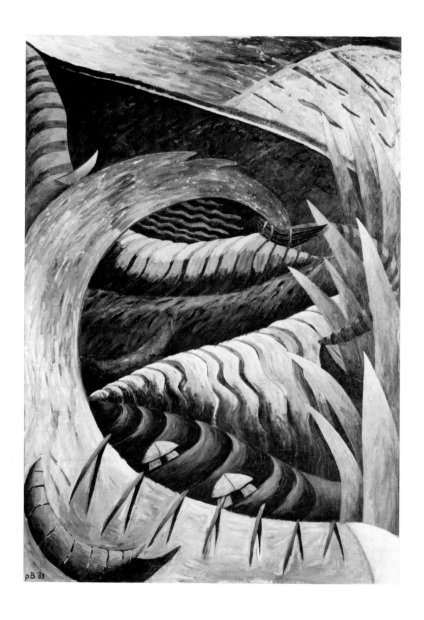

10.
Snake Wave. 1983
Acrylic and mixed media on canvas, 73 x 52"
Courtesy of the artist and Fuller Goldeen
Gallery, San Francisco

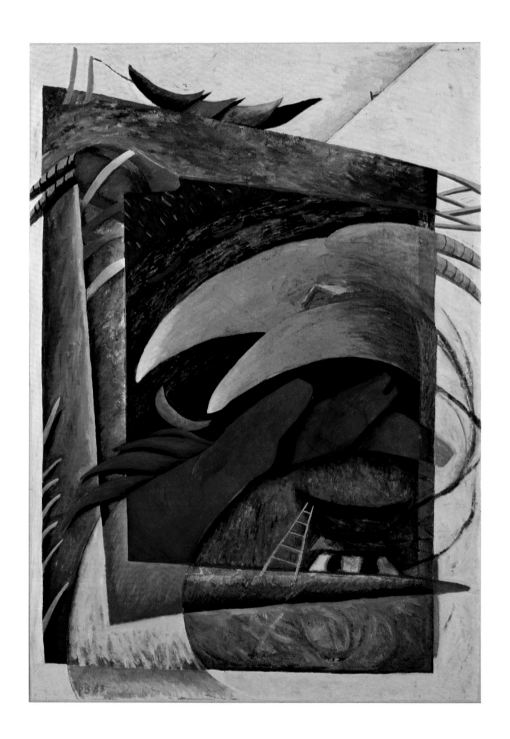

11.
Big Sea II. 1983
Acrylic and mixed media on canvas, 94 x 67″

Courtesy of the artist and Fuller Goldeen
Gallery, San Francisco

Bruce Cohen

Born in Los Angeles, December 26, 1953

University of California, Los Angeles, 1972

University of California, Berkeley, 1974

University of California, Santa Barbara, B.F.A., 1975

Lives and works in Los Angeles

Selected Group Exhibitions

Jodi Scully Gallery, Los Angeles, June-July 1977

Tortue Gallery, Los Angeles, *Introductions: 1978,* July 18-August 26, 1978

Newport Harbor Art Museum, Newport Beach, California, *Betty Asher's Cups,* December 13, 1980-January 11, 1981. Traveled to Triton Museum of Art, Santa Clara, California, April 4-May 2, 1982

University Art Galleries, University of Southern California, Los Angeles, *Portraits in Miniature and U.S.C.'s Tribute to Africa,* October 25-November 20, 1981

John Berggruen Gallery, San Francisco, *Selected Works,* April 6-May 7, 1983

Laguna Beach Museum of Art, California, *West Coast Realism,* June 3-July 24, 1983. Catalogue with text by Lynn Gamwell. Traveling to Museum of Art, Fort Lauderdale, November 1-December 4, 1983; Center for Visual Arts, Illinois State University, Normal, January 15-February 28, 1984; Fresno Art Center, California, April 1-May 13; Louisiana Arts and Science Center, Baton Rouge, June 3-July 15; Museum of Art, Bowdoin College, Brunswick, Maine, September 7-November 4; Colorado Springs Fine Arts Center, November 20-December 18; Spiva Art Center, Joplin, Missouri, January 6-February 15, 1985; Beaumont Art Museum, Texas, March 8-April 21; Sierra Nevada Museum of Art, Reno, May 5-June 16;

Edison Community College, Fort Meyers, Florida, July 7-August 18

Selected One-Man Exhibitions

University of California, Santa Barbara, *Graduate Show,* February 21-27, 1975

Asher/Faure, Los Angeles, August 15-September 12, 1981

Asher/Faure, Los Angeles, January 8-February 5, 1983

Selected Bibliography

Henry Seldis, "Artwalk," *Los Angeles Times,* June 24, 1977, p. 10

Robert L. Pincus, "Cohen, Michelson Exhibit Paintings," *Los Angeles Times,* August 28, 1981, part VI, p. 4

Suzanne Muchnic, "Mini Portraits at USC Art Gallery," *Los Angeles Times,* November 12, 1981, part VI, p. 3

William Wilson, "The Galleries," *Los Angeles Times,* January 21, 1983, part VI, p. 10

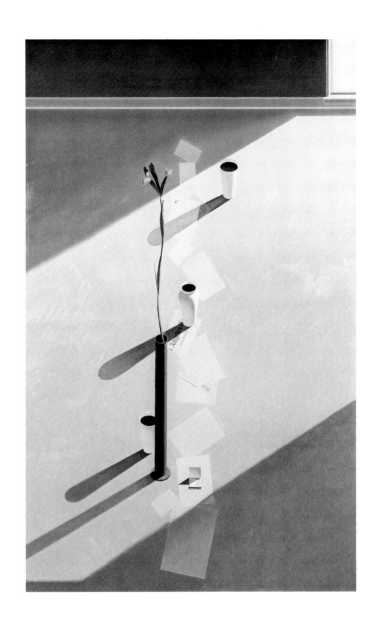

12.
Untitled. 1981
Oil on canvas, 68½ x 42″
Collection Mr. and Mrs. Bryan Cooke

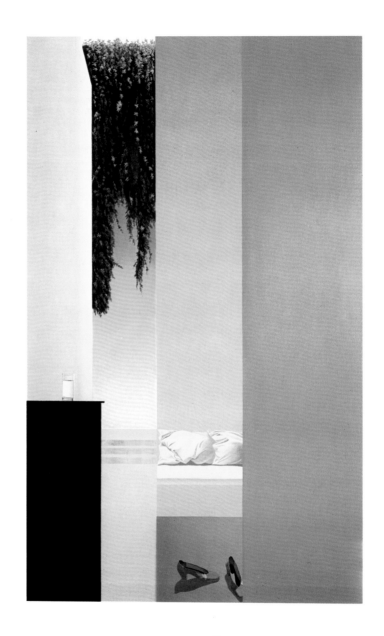

13.
Untitled. 1982
Oil on canvas, 68½ x 42″
Courtesy Asher / Faure, Los Angeles

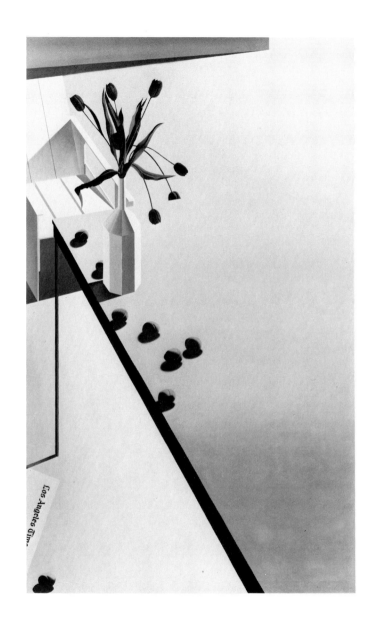

14.
Untitled. 1982
Oil on canvas, 66 x 40″
Collection Leon and Evelyn Alschuler

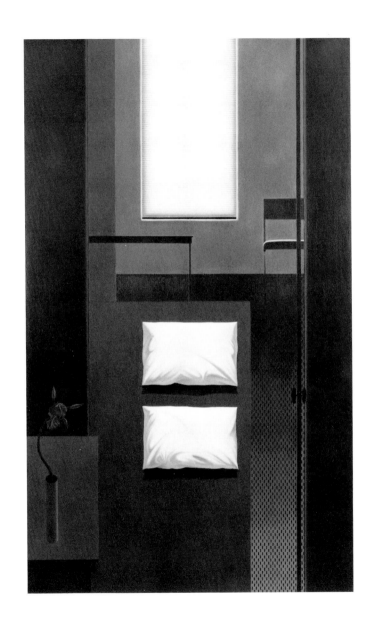

15.
Untitled. 1982
Oil on canvas, 66 x 40″
Private Collection

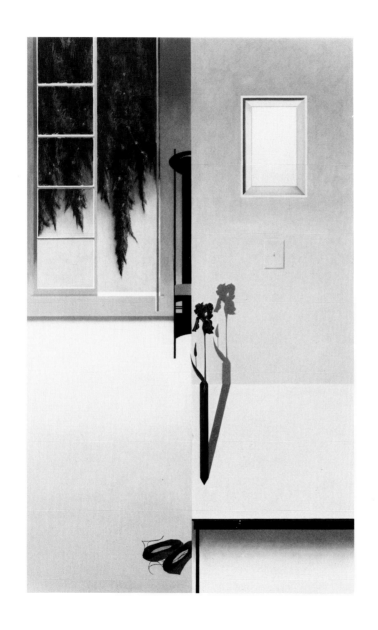

16.
Untitled. 1982
Oil on canvas, 66 x 40″
Collection Stephen Berg, Beverly Hills

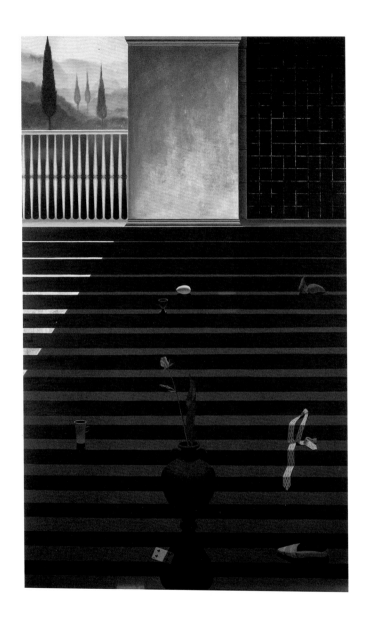

17.
Untitled. 1982
Oil on canvas, 66 x 40″
Collection Werner and Mimi Wolfen

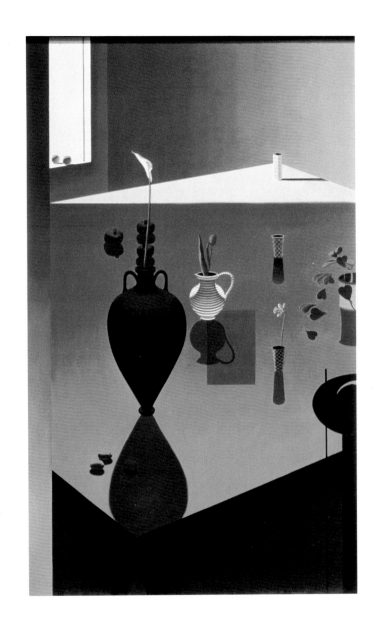

18.
Untitled. 1982
Oil on canvas, 66 x 40″
Collection David M. Marcus, Los Angeles

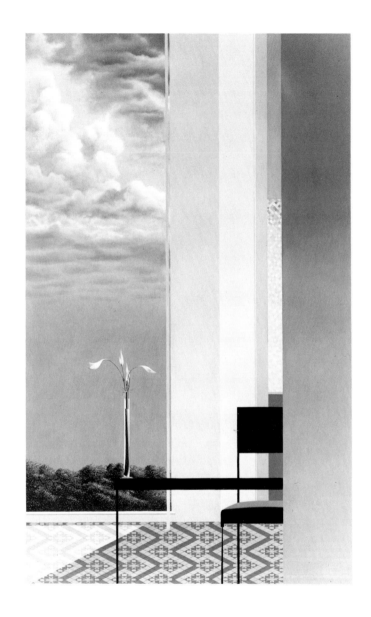

19.
Untitled. 1982
Oil on canvas, 66 x 40˝
Collection Robert Nachshin and Monica Lipkin,
Los Angeles

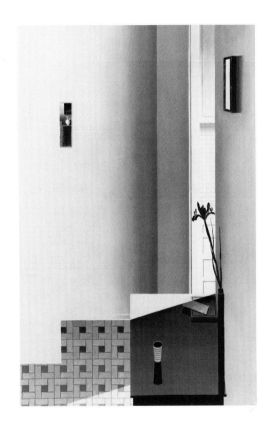

20.
Study for Untitled. 1982
Oil on canvas, 22 x 14″
Courtesy Asher/Faure, Los Angeles

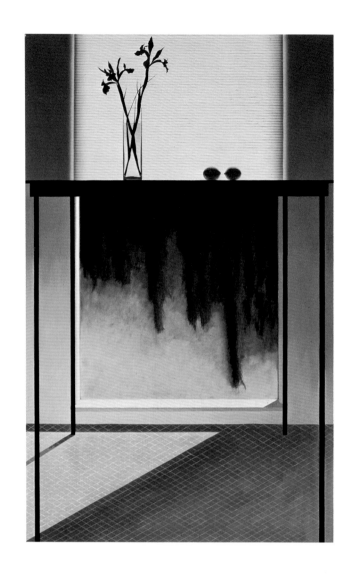

21.
Untitled. 1983
Oil on canvas, 50 x 30"
Collection Carol Burnett

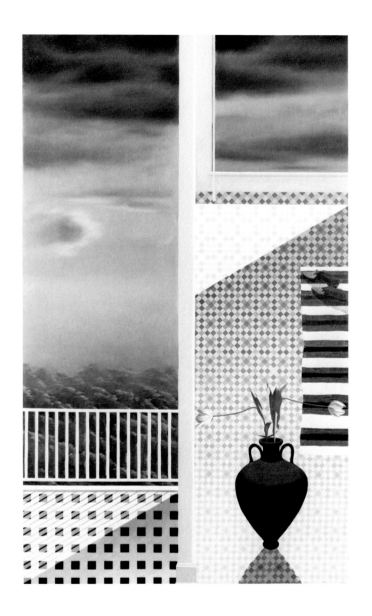

22.
Untitled. 1983
Oil on canvas, 66 x 40″
Courtesy Asher/Faure, Los Angeles

Julie Cohen

Born in New York, April 24, 1955
Pratt Institute, Brooklyn, 1973
Ithaca College, New York, 1974-76
School of Visual Arts, New York, B.F.A., 1979
Hunter College, New York, M.A., 1982
Teaches at School of Visual Arts, New York,
1982-present
Lives and works in New York

Group Exhibition

The Institute for Art and Urban Resources/
P.S. 1, Long Island City, New York, *Space
Invaders,* April 4-May 30, 1982. Installation in
collaboration with Frank Holliday

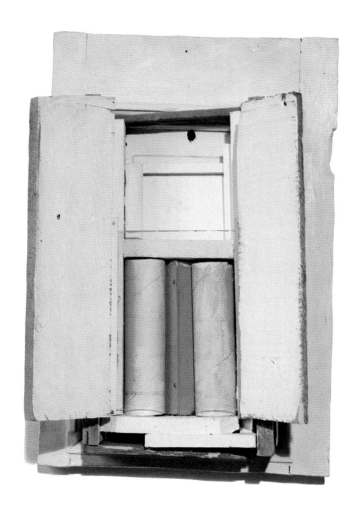

23.
Untitled #2. 1981
Wood, gesso, acrylic and oil, 18 x 12 x 6″
Collection Avron and Sheila Brog, New York

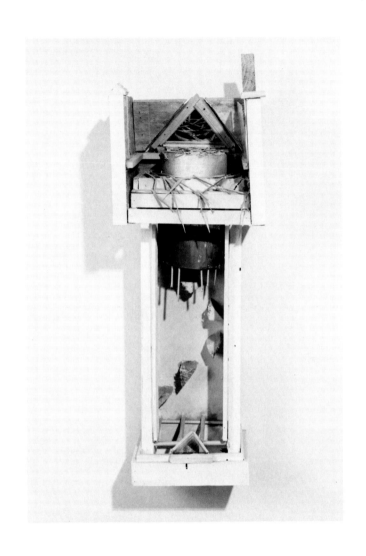

24.
Untitled #3. 1981
Wood, gesso, acrylic and oil, 24 x 8 x 9″
Collection of the artist

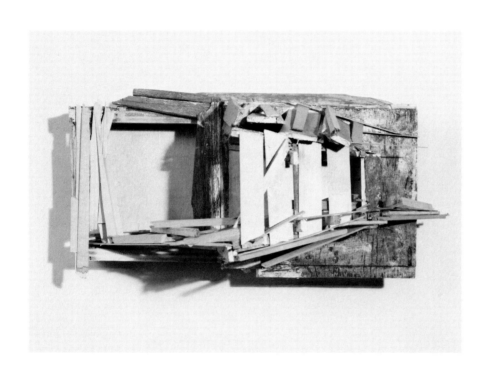

25.
Untitled #4. 1982
Wood, gesso, acrylic and oil, 9 x 18 x 12″
Private Collection, New York

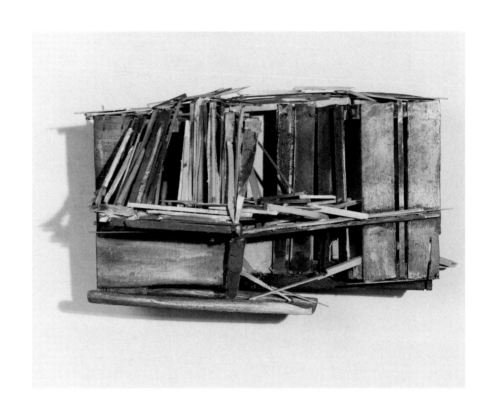

26.
Untitled #5. 1982
Wood, gesso, acrylic and oil, 10 x 18 x 6″
Collection Robert and Maureen Kassel,
New York

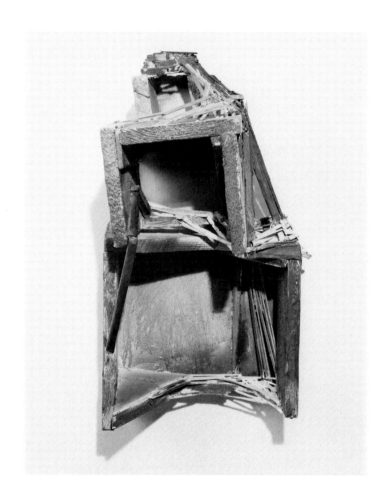

27.
Untitled #8. 1982
Wood, gesso, acrylic and oil, 18 x 10 x 11″
Collection Marilyn and David Rhodes,
New York

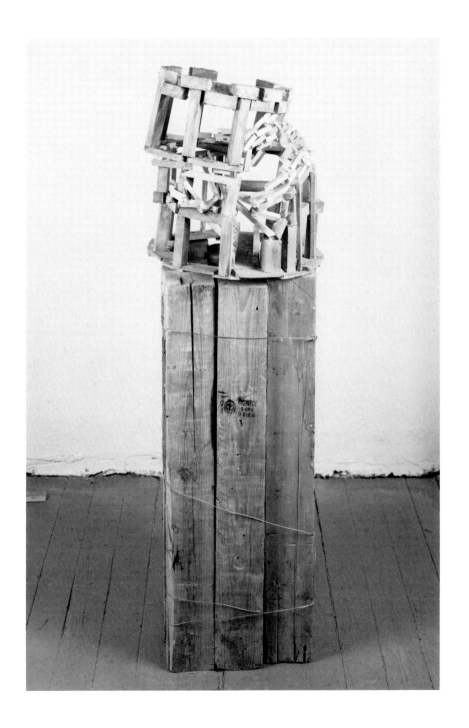

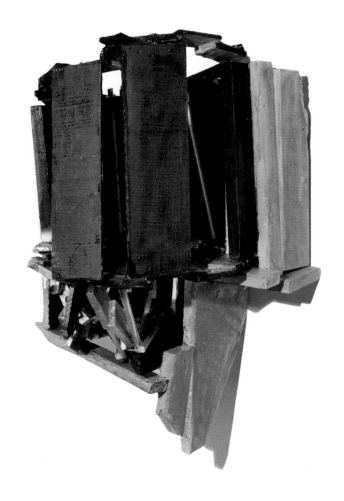

28.
Untitled #9. 1982
Wood, gesso, acrylic and oil, 42 x 12 x 12"
Collection of the artist

29.
Untitled #15. 1983
Wood, gesso, acrylic and oil, 23 x 17 x 15"
Collection of the artist

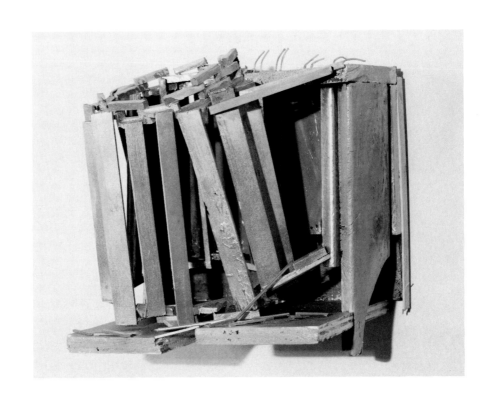

30.
Untitled #17. 1983
Wood, gesso, acrylic and oil, 12 x 12 x 11″
Collection of the artist

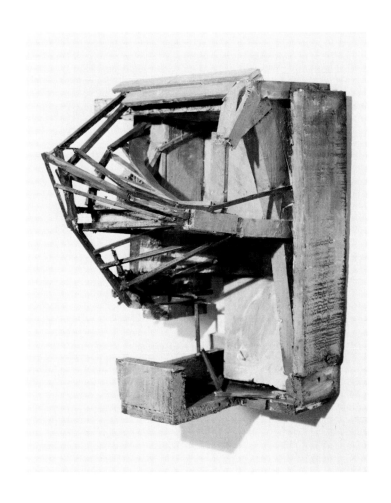

31.
Untitled #16. 1983
Wood, gesso, acrylic and oil, 12 x 5 x 10″
Collection of the artist

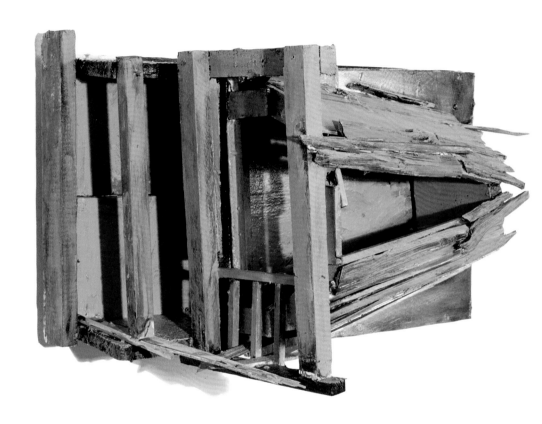

32.
Untitled #18. 1983
Wood, gesso, acrylic and oil, 12 x 18 x 11″
Collection of the artist

Scott Davis

Born in Washington, D.C., September 4, 1944

University of California at Davis, M.F.A., 1974

Whitney Studio Program, Whitney Museum of
American Art, New York, 1974

Tiffany Foundation Award, 1981

Lives and works in New York

Selected Group Exhibitions

The Museum of Modern Art, New York, Art
Lending Service, *76 Jefferson,* September 11-
December 1, 1975

Artists Space, New York, *Auction Show,*
January 7-22, 1977

112 Greene Street, New York, *Group
Invitational,* Winter 1977

White Columns, New York, *3/7/3,* March
10-28, 1981

The Solomon R. Guggenheim Museum, New
York, *New Acquisitions,* October 6-
November 29, 1981

Cincinnati Art Museum, *Cincinnati Collects
Paintings*, March 31-May 15, 1983

One-Man Exhibitions

The Institute for Art and Urban Resources/
P.S. 1, Projects Room, Long Island City, New
York, December 7, 1980-January 25, 1981

33.
Eleusinian Mysteries "Untitled." 1979
Oil on canvas, 50 x 50"
Collection of the artist

34.
Eleusinian Mysteries "Smile." 1980
Oil on canvas, 23 x 57"
Collection of the artist

35.
Eleusinian Mysteries "Untitled." 1980
Oil on canvas, 51 x 84"
Collection of the artist

36.
Eleusinian Mysteries ''Scribe.'' 1981
Oil on canvas, 48″ diameter
Collection of the artist

37.
Thinking and Working "Maine." 1982
Oil on canvas, 42 x 44″
Collection of the artist

38.
Untitled. 1983
Oil on canvas, 36″ diameter
Collection of the artist

39.
Untitled. 1983
Oil on canvas, 46 x 64″
Collection of the artist

40.
Circle, Cross and Square. 1983
Oil on canvas, 46 x 46″
Collection of the artist

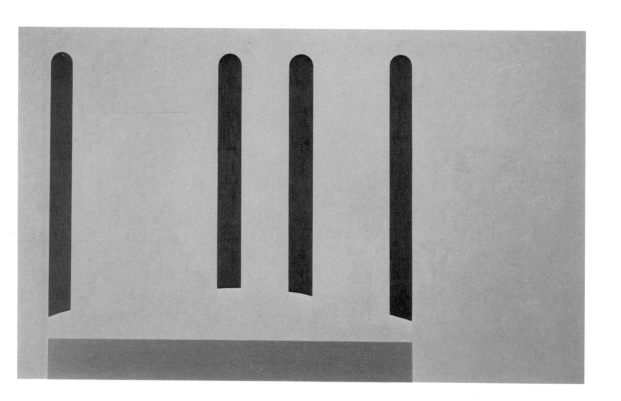

41.
Thinking and Working "The Garden (Poussin's
Backyard)." 1983
Oil on canvas, 51 x 84"
Collection of the artist

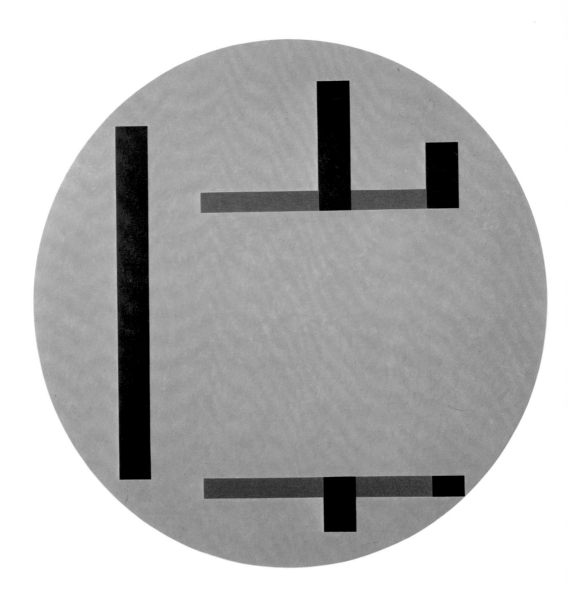

42.
Thinking and Working "Real Time." 1983
Oil on canvas, 72″ diameter
Collection of the artist

Steve Duane Dennie

Born in Dallas, December 25, 1954

North Texas State University, Denton, B.F.A., 1979

Curator of Photography, Delahunty Gallery, Dallas, 1981—present

Lives and works in Dallas

Selected Group Exhibitions

Laguna Gloria Art Museum, Austin, *Texas Fine Arts Association 67th Annual Exhibition,* April 22-June 3, 1978

Second Street Gallery, Charlottesville, Virginia, *National Print, Drawing and Photography Exhibition,* April 28-June 2, 1978. Catalogue

Arkansas Art Center, Little Rock, *Eleventh Annual Prints, Drawings and Crafts Exhibition,* May 12-June 11, 1978

Chrysler Museum, Norfolk, Virginia, *Light Images: Friends of Photography,* July 14-August 20, 1978

Downey Museum of Art, California, *Los Angeles Center for Photographic Studies First Juried Show,* November 18-December 21, 1978

D.W. Co-op Gallery, Dallas, *Trees,* December 1-31, 1978

North Texas State University Gallery, Denton, *Good Bye Earth, So Long Valentine,* April 1-7, 1979

Central Washington University, Ellensburg, *New Photographics/80,* April 28-May 23, 1980. Traveled in modified form to East Tennessee State University, Johnson City, 1980; Fine Arts Gallery, The Evergreen State College, Olympia, Washington, 1981; Gallery, Division of Fine Arts, College of the Redwoods, Eureka, California, 1981

Contemporary Arts Museum, Houston, *The New Photography,* January 17-February 22, 1981. Catalogue with texts by Linda Cathcart and Marti Mayo

500 Exposition Gallery, Dallas, *Photoworks: Steve Dennie/Nic Nicosia,* April 11-May 9, 1981

Galveston Art Center, Texas, *Steve Dennie/ Nic Nicosia,* November 6-29, 1981

Hallwalls and C.E.P.A. Gallery, Buffalo, February 7-27, 1982

The New Orleans Museum of Art, *The New Orleans Triennial,* April 8-May 22, 1983. Catalogue with text by Linda Cathcart

North Texas State University, Art Department Gallery, Denton, *Making Photographs: Six Alternatives,* August 29-September 16, 1983

One-Man Exhibition

Wichita Falls Memorial Auditorium, Texas, *Ground Works,* February 1-28, 1979

Selected Bibliography

John Scarborough, "Artists Combine Latent Image With Other Media," *Houston Chronicle,* February 5, 1981, section 3, p. 7

Susan Kalil, "Photographic Cross-Currents," *Artweek,* vol. 12, February 7, 1981, p. 1

Robert Raczka, "Stephen Dennie and Nic Nicosia," *Artspace Quarterly,* vol. 5, Fall 1981, pp. 62-63

Anthony Bannon, "Big New Colorful Photographs," *The Buffalo News,* February 7, 1982, p. G 1

Anthony Bannon, "Noble Images Used to Transform Magazine Photographs into Art," *Buffalo Evening News,* February 16, 1982, p. G 1

Richard Huntington, "Neutrality of Camera Evidenced in Two," *Buffalo Courier-Express,* February 21, 1982, p. 1, F 3

Roger Green, "Controversy at N.O.M.A.'s Tri-
ennial," *Times-Picayune*, April 17, 1983,
section 3, pp. 2-3

Susan Kalil, "1983 New Orleans Triennial: An
Interview with Guest Curator Linda Cathcart,"
Arts Quarterly, New Orleans Museum of Art,
vol. 5, April-June 1983, pp. 1-14

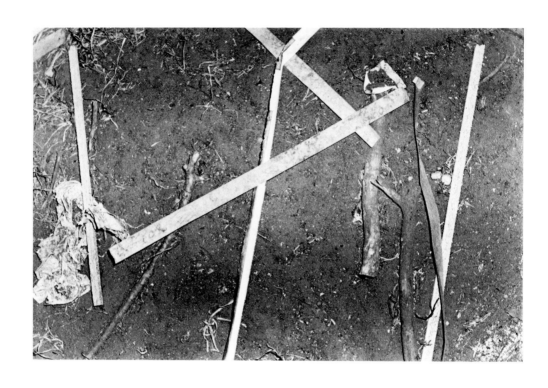

43.
Untitled #1. 1978-79
Hand-colored silver print, 2 parts, total
23¾ x 70″
1/3
Collection of the artist; courtesy Delahunty
Gallery, Dallas and New York

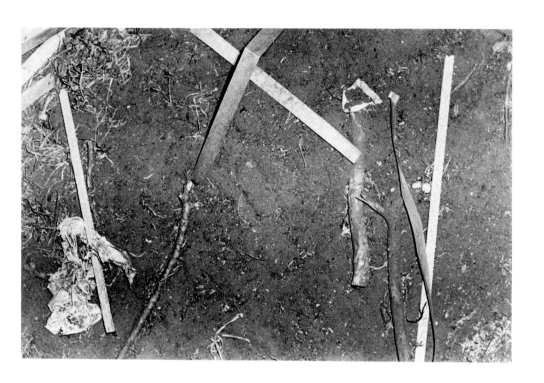

75

44.
Untitled. 1978-79
Hand-colored toned silver print, 23¾ x 35"
1/3
Collection of the artist; courtesy Delahunty
Gallery, Dallas and New York

45.
Untitled. 1980
Hand-colored silver print, 23¾ x 35¾"
Collection of the artist; courtesy Delahunty
Gallery, Dallas and New York

46.
Untitled. 1980
Hand-colored toned silver print, 24 x 36″
Courtesy Delahunty Gallery, Dallas and New York

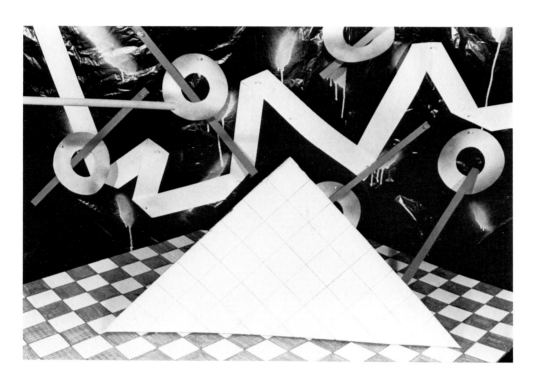

47.
Cut Paper #14. 1981
Hand-colored silver print, 24 x 36″
1/5
Collection of the artist; courtesy Delahunty
Gallery, Dallas and New York

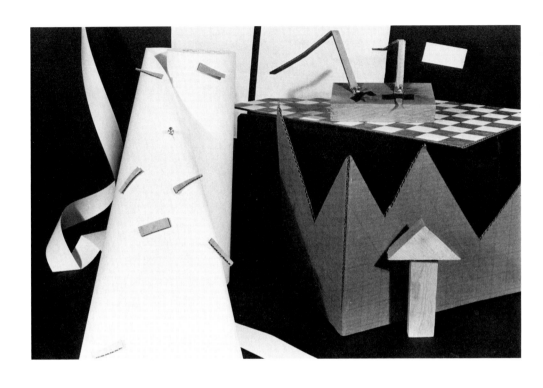

48.
Cut Paper #19. 1981
Hand-colored silver print, 24 x 36″
2/5
Collection of the artist; courtesy Delahunty
Gallery, Dallas and New York

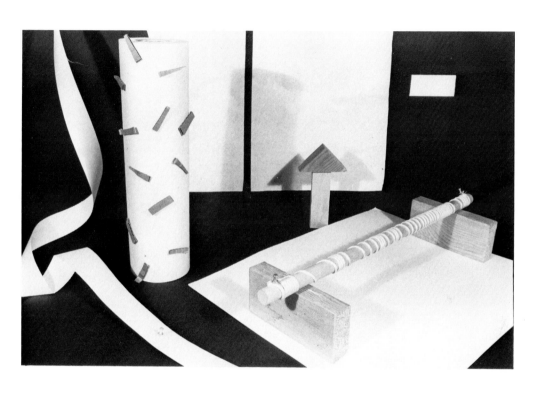

49.
Cut Paper #20. 1981
Hand-colored silver print, 24 x 36″
2/5
Collection of the artist; courtesy Delahunty
Gallery, Dallas and New York

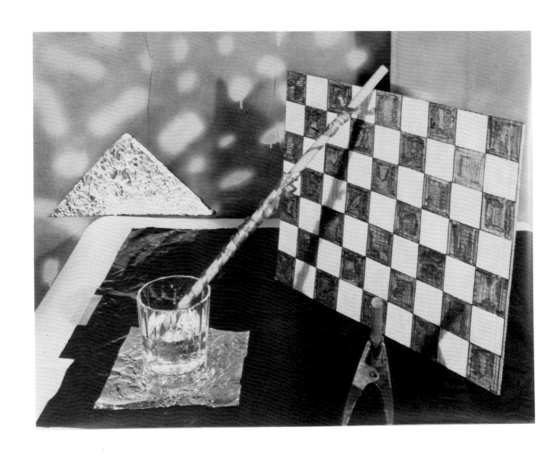

50.
Cut Paper #21. 1982
Hand-colored silver print, 2 parts, total 24 x 60"
1/5
Collection of the artist; courtesy Delahunty
Gallery, Dallas and New York

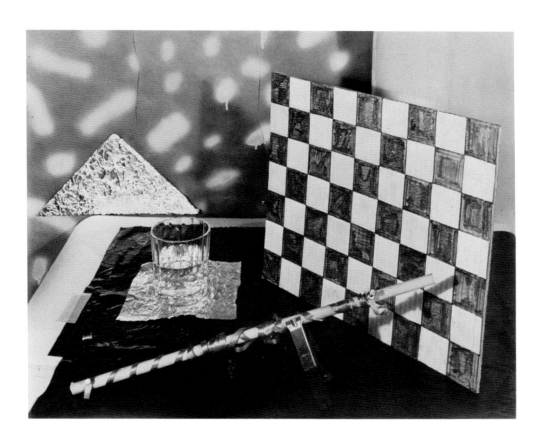

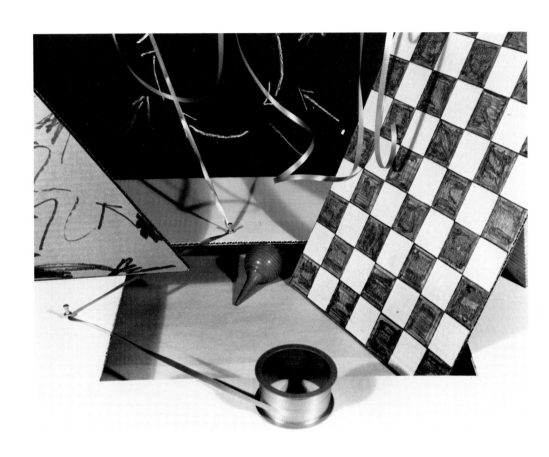

51.
Cut Paper #22. 1982
Hand-colored silver print, 2 parts, total 24 x 62"
2/5
Collection of the artist; courtesy Delahunty
Gallery, Dallas and New York

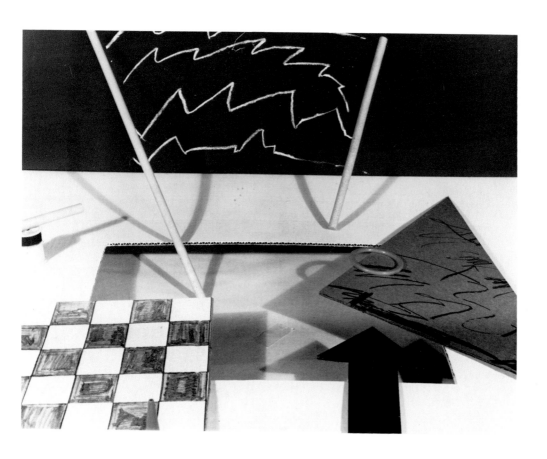

Carol Hepper

Born in McLaughlin, South Dakota, October 23, 1953

South Dakota State University, Brookings, B.S., 1975

National Educational Broadcasters Award for Television Set Design, 1979

Betty Brazil Memorial Grant, 1981

Individual Artist's Mini Grant, South Dakota Arts Council, 1981

Individual Artist's Fellowship, South Dakota Arts Council, 1982

Lives and works near McLaughlin, South Dakota

Selected Group Exhibitions

Ligoa Duncan Gallery, New York, *Salon of the 50 States,* May 1-31, 1978

Art Association of Newport, Rhode Island, 67th *American Annual Exhibition,* November 18-December 10, 1978

Newspace Gallery, Corvallis, Oregon, *National Small Format, Mixed Media Show,* May 1-30, 1979. Catalogue

Jacksonville Art Museum, Florida, *Members Juried Exhibition,* October 18-November 18, 1979. Catalogue

Flagler College Gallery, St. Augustine, Florida, *Flagler College Faculty Exhibition,* March 9-17, 1980

South Dakota Memorial Art Center, Brookings, *South Dakota Biennial V,* March 8-April 19, 1981. Traveled in South Dakota through November 1981

Del Mar College, Corpus Christi, Texas, *15th Annual National Drawing and Small Sculpture Show,* March 29-April 30, 1981. Catalogue with text by Ivan Karp

Foremost Gallery, Sioux Falls, South Dakota, *Darkhorse,* May 1-31, 1981

Lincoln Hall Gallery, Northern State College, Aberdeen, South Dakota, *Small Works,* November 1-30, 1981

55 Mercer Gallery, New York, *South Dakota Experimental Artists,* September 7-25, 1982

W.A.R.M. Gallery (Invitational Space), Minneapolis, December 19, 1982-January 18, 1983. Installation and video

North Dakota Museum of Art, Grand Forks, *Descendants,* April 14-August 12, 1983. Catalogue with text by Laurel Reuter

South Dakota Memorial Art Center, Brookings, *South Dakota Biennial VI,* May 1-June 26, 1983

Selected One-Woman Exhibitions

Flagler College Gallery, St. Augustine, Florida, February 4-18, 1979

Brookings Cultural Center, South Dakota, December 3-31, 1980

Coffman Gallery, University of Minnesota, Minneapolis, November 16-December 9, 1981

The Institute for Art and Urban Resources/P.S. 1, Long Island City, New York, January 17-March 14, 1982

Selected Bibliography

Don Boyd, *Art Express,* vol. 1, May-June 1981, p. 80

Palmer Poroner, "Art of Primitive Origins or Great Traditions," *Artspeak,* vol. IV, September 16, 1982, p. 5

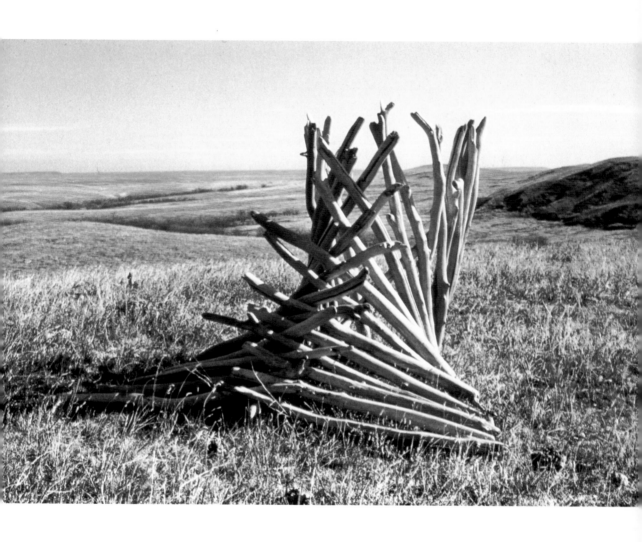

52.
Passage. 1980
Driftwood, 48 x 72 x 57"
Collection of the artist

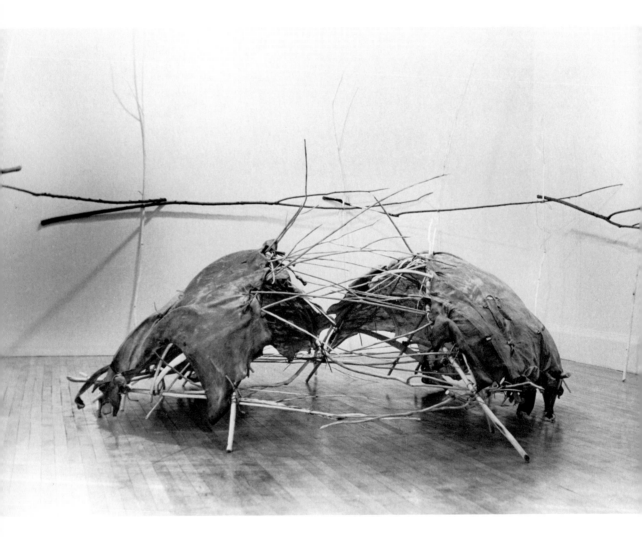

53.
W.A.R.M. Piece. 1981
Mixed media, 30 x 84 x 96″
Collection of the artist

54.
Windows. 1981
Mixed media, 67 x 43 x 32″
Collection of the artist

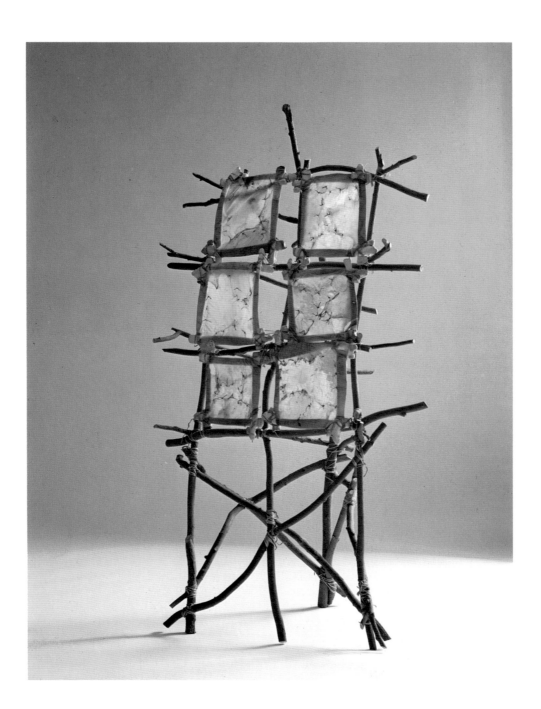

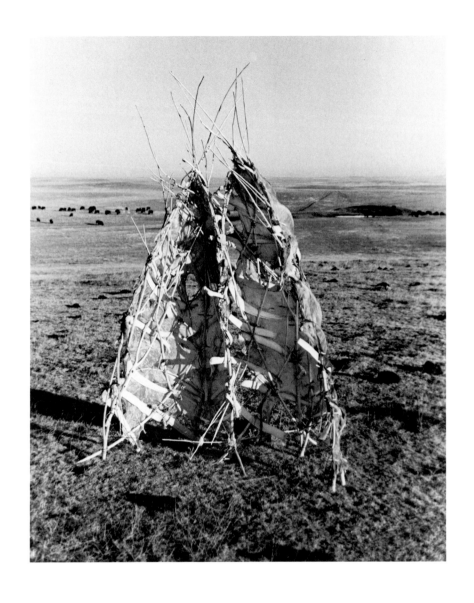

55.
Double Chamber. 1981
Mixed media, 79 x 29 x 65″
Collection of the artist

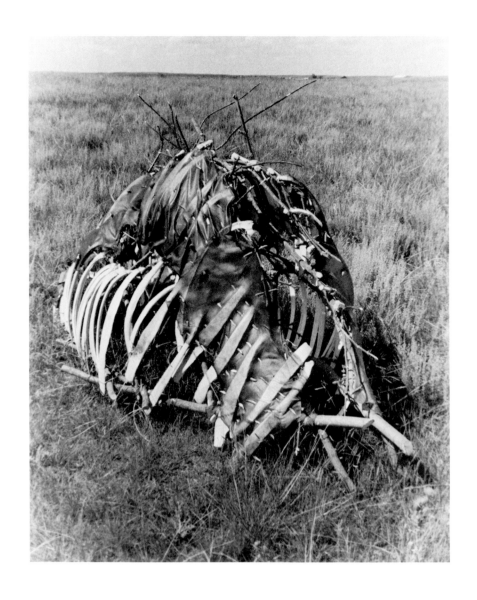

56.
Pierced / Pegged. 1981
Mixed media, 44 x 99 x 56"
Collection The Dannheisser Foundation

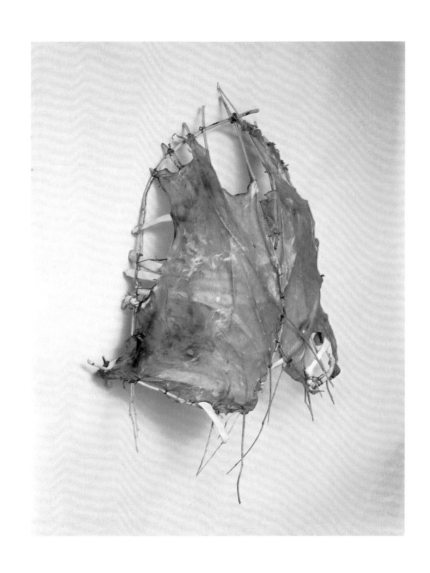

57.
Wall Piece. 1982
Mixed media, 52 x 54 x 17″
Collection Earl Willis, New York

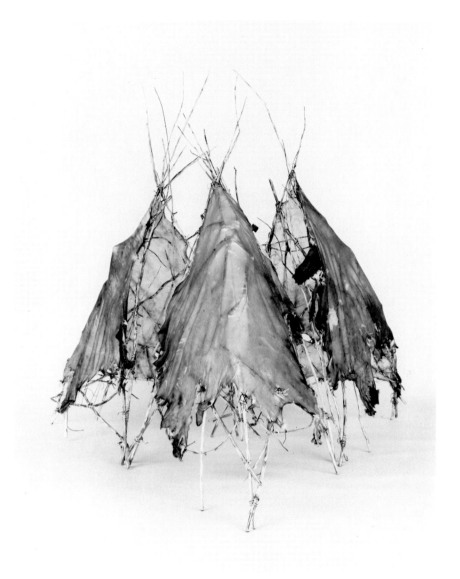

58.
Three Chambers. 1982
Mixed media, 3 sections, each 63 x 29 x 43";
total 63 x 86 x 86"
Collection of the artist

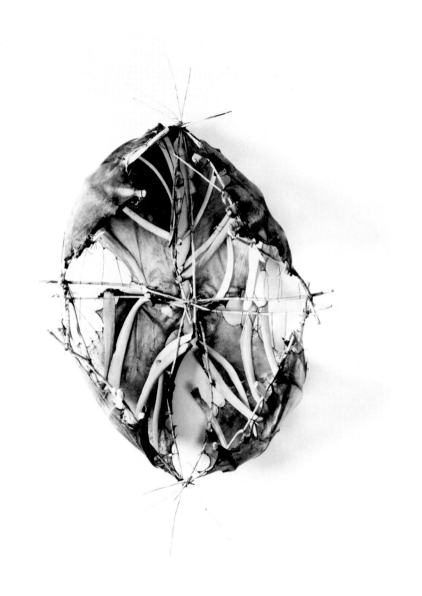

59.
Four Chambers. 1982
Mixed media, 64 x 56 x 32″
Collection of the artist

Whit Ingram

Born in Pasadena, December 2, 1948

University of California, Berkeley, B.A., 1971; M.A., 1974

John and Elliot Wheeler Fellowship, 1973

James T. Phelan Scholarship, 1974

Currently lives and works in San Francisco

Selected Group Exhibitions

Oakland Museum, California, *Metal Experience,* June 5-July 5, 1971

Guild Hall, East Hampton, New York, *Young Artists,* July 1-30, 1972

Nelson Art Gallery, University of California, Davis, *Berkeley / Davis: Exchange Show,* April 8-May 3, 1974

Worth Ryder Art Gallery, University of California, Berkeley, *James T. Phelan Award Exhibition,* January 1-31, 1975

Hansen Fuller Gallery, San Francisco, *Introductions '75,* July 8-August 2, 1975

Hansen Fuller Gallery, San Francisco, *Gallery Group Show,* August 5-September 9, 1975

Oakland Museum, California, *Bay Area Artists: Exhibition and Sale,* August 22-28, 1975

Hansen Fuller Gallery, San Francisco, *Gallery Group Show,* August 6-September 7, 1976

Galerie Grace, Palo Alto, California, *Works on Paper,* February 3-March 1, 1979

Hansen Fuller Goldeen Gallery, San Francisco, *Polychrome,* December 2, 1981-January 2, 1982

Art Gallery, California State University, Northridge, *New Bay Area Painting and Sculpture,* October 25-November 24, 1982. Catalogue with text by Christopher Brown and Judith Dunham. Traveled to San Francisco Art Institute, December 7, 1982-January 7, 1983

Selected One-Man Exhibitions

Worth Ryder Art Gallery, University of California, Berkeley, November 26-December 1, 1973

Braunstein/Quay Gallery, San Francisco, November 1-26, 1977

Braunstein/Quay Gallery, New York, June 6-July 1, 1978

Selected Bibliography

Judith L. Dunham, "A Variety of Materials Deftly Used," *Artweek,* vol. 6, July 26, 1975, p. 5

Peter Plagens, "Introductions '75," *Artforum,* vol. XIV, October 1975, pp. 72-74

Allie Anderson, "Voices Choices," *The Village Voice,* July 3, 1978, p. 51

Josine Ianco-Starrels, "Artists from the Bay to L.A.," *Los Angeles Times,* October 31, 1982

William Wilson, "Recycling of New and Neo," *Los Angeles Times,* November 7, 1982, pp. 82-83

Suzaan Boettger, "Polymorphous Perversity," *San Francisco Bay Guardian,* December 22, 1982, pp. 46, 51-52

Cathy Curtis, "Seeking the New Bay Area: Painting and Sculpture," *Artweek,* vol. 13, December 25, 1982, pp. 1, 16

Allan Temko, "Young Artists with Little Sparkle," *San Francisco Chronicle,* January 5, 1983, p. 54

Jeff Kelley," New Bay Area Painting and Sculpture," *Vanguard,* vol. 12, April 1983, pp. 16-19

Andrea Liss, "New Bay Area Painting and Sculpture at the San Francisco Art Institute," *Images & Issues,* vol. 3, May/June 1983, pp. 65-66

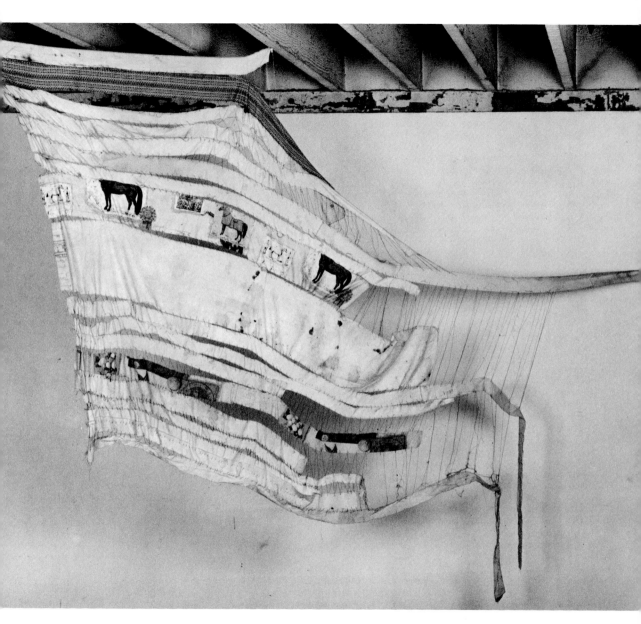

60.
Untitled. 1975
Cloth and thread, 60 x 108″
Collection of the artist

97

61.
Untitled. 1975
Watercolor, crayon and collage, 23¼ x 35″
Collection Mr. and Mrs. Matthew D. Ashe,
Sausalito, California

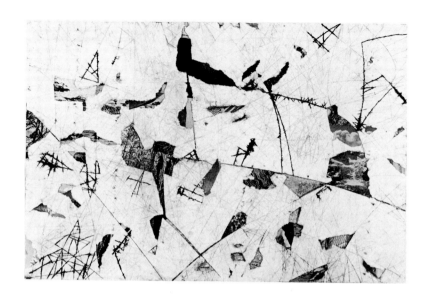

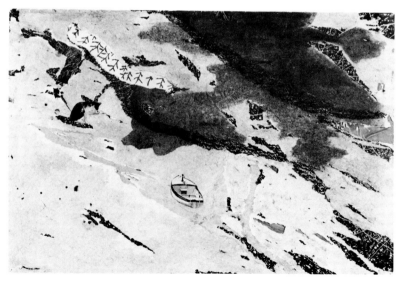

62.
Untitled. 1975
Watercolor and collage, 23½ x 35″
Collection Mrs. Richard M. Duff,
Kentfield, California

63.
Untitled. 1975
Watercolor, crayon and collage, 23 x 34½″
Private Collection

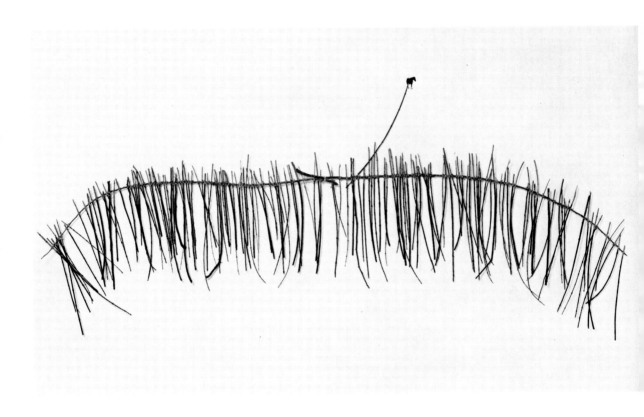

64.
Stick Piece. 1971-77
Sticks, cane, acrylic and collage, 28 x 96″
Collection Mr. and Mrs. Robert I. McCarthy

65.
Camel Collage. 1977
Wood, metal and collage, 24 x 84″
Collection Sylvia Brown, San Francisco

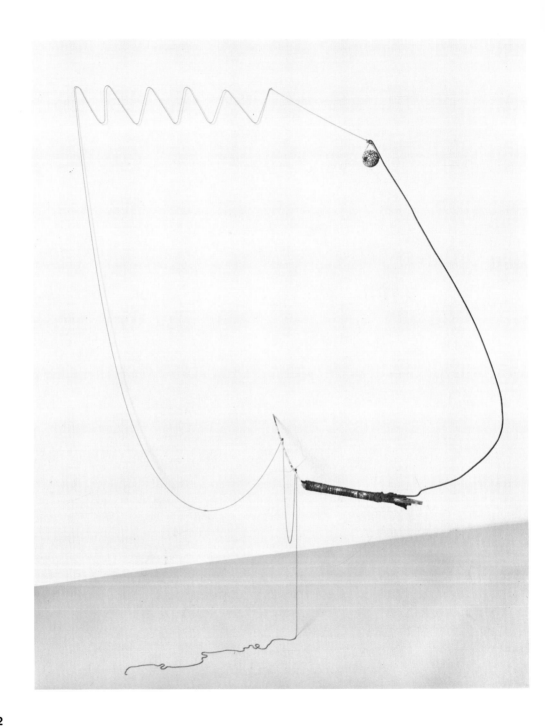

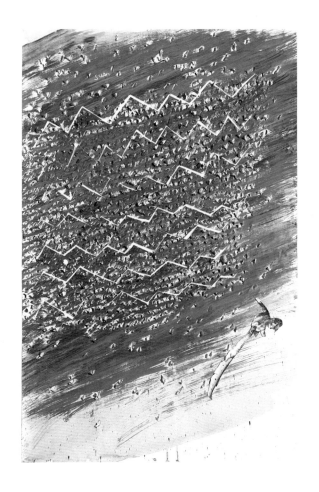

66.
Buffalo Fish. 1978
Mixed media, 72 x 36 x 46″
Collection of the artist

67.
Pelican Sweep. 1979
Watercolor and collage, 34 x 24″
Collection Mr. and Mrs. John G. Rogers

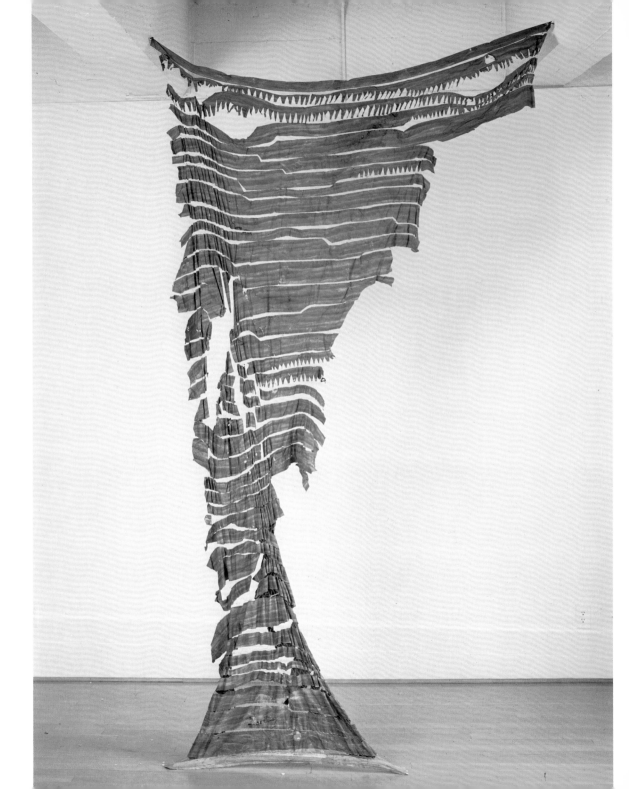

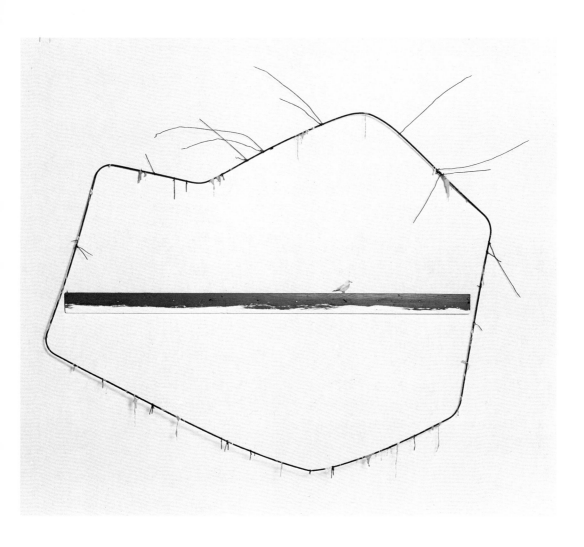

68.
Blue Cloth. 1979
Cloth and thread, 119 x 79"
Collection of the artist

69.
Wind, Bird, Ocean. 1982
Mixed media, 60 x 83½ x 2¼"
Collection of the artist

Aaron Karp

Born in Altoona, Pennsylvania, December 7, 1947

Fellowship for study in India, State University of New York, College at Buffalo, 1968-69

State University of New York, College at Buffalo, B.A., 1969

Indiana University, Bloomington, M.F.A., 1971

Faculty Research Grant, East Carolina University, Greenville, North Carolina, 1978

Assistant Professor, Painting, Drawing, Fundamentals, University of New Mexico, Albuquerque, 1979-present

Research Allocation Grant, University of New Mexico, Albuquerque, 1980, 1982

Artist-in-Residence Grant, Roswell Museum and Art Center, New Mexico, 1981-82

Lives and works in Albuquerque

Selected Group Exhibitions

North Carolina Museum of Art, Raleigh, *40th Annual North Carolina Artists Exhibition,* December 1, 1977-January 8, 1978

Chrysler Museum, Norfolk, Virginia, *24th Irene Leache Memorial Exhibition,* March 12-April 30, 1978

North Carolina Museum of Art, Raleigh, *Reynolds Collection,* Spring 1978

Cheney Cowles Memorial Museum, Spokane, Washington, *Third Spokane National '79,* January 4-February 4, 1979

North Carolina Museum of Art, Raleigh, *Systems,* February 18-March 11, 1979

Southeastern Center for Contemporary Art, Winston-Salem, North Carolina, *Six Painters,* March 3-April 18, 1979

Downtown Center for the Arts, Albuquerque, *Albuquerque Contemporary Arts Exhibition,* September 29-October 31, 1979

Downtown Center for the Arts, Albuquerque, *References: Painting of a Sort,* November 2-29, 1979

Roswell Museum and Art Center, New Mexico, *Fall Invitational,* September 14-November 2, 1980. Catalogue

Albuquerque Museum, *Recent Acquisitions,* November 1981-October 1982

Albuquerque Museum, *Selections from the Permanent Collection,* March 7-September 24, 1982

Mattingly-Baker Gallery, Dallas, April 3-29, 1982

The Solomon R. Guggenheim Museum, New York, *Recent Acquisitions,* July 1-September 6, 1982

Mattingly-Baker Gallery, Dallas, Summer 1982

Leslie Levy Gallery, Scottsdale, Arizona, Summer-Fall 1982

Sebastian-Moore Gallery, Denver, September 9-October 23, 1982

Wildine Galleries, Albuquerque, Fall 1982

Leslie Levy Gallery, Scottsdale, *Santa Fe Comes to Scottsdale,* February 24-March 21, 1983

Wildine Galleries, Albuquerque, April 1-30, 1983

Davis McClain Gallery, Houston, *Introductions,* July 1983

Selected One-Man Exhibitions

Wildine Galleries, Albuquerque, March 21-April 19, 1980

Leslie Levy Gallery, Scottsdale, April 9-30, 1981

Wildine Galleries, Albuquerque, *Recent Paintings,* October 16-November 13, 1981

Leslie Levy Gallery, Scottsdale, *New Paintings,* February 4-23, 1982

Roswell Museum and Art Center, New Mexico,

Artist-In-Residence Grant Exhibition, June 6-
July 4, 1982

Selected Bibliography

Patricia Krebs, "Green Hill Show Features
Dimensional Juggling Act," *Greensboro Daily
News,* Wednesday, April 26, 1978, p. C 8

Jennie Lusk, "Huge Exhibition Fills Two Gal-
leries," *Albuquerque Journal,* October 7, 1979

Keith Raether, "City's Art Octoberfest a Suc-
cess," *The Albuquerque Tribune,* October 10,
1979, p. B 2

Kathleen Shields, "References: Paintings of a
Sort at AUA, Albuquerque," *Artspace,* vol. 5,
Winter 1980

Keith Raether, "Karp Exhibit Set for Wildine
Galleries," *The Albuquerque Tribune,* March
12, 1980

Jennie Lusk, "Aaron Karp Paintings Dynamic
Works with Dazzling Tension," *Albuquerque
Journal,* March 30, 1980, p. D 3

Dana Asbury, "Aaron Karp," *Artspace,* Winter
1981, pp. 38-39

Deb Adler, "Works Reveal -and Hide- Artist,"
Scottsdale (Ariz.) Daily Progress-Weekend,
February 12, 1982, p. 36

Barbara Cortright, *Scottsdale (Ariz.) Daily
Progress-Weekend,* February 12, 1982, p. 35

Kathy Shields and Steve Shipp, "The World
According to Aaron Karp," *Arizona Arts &
Lifestyle,* Winter 1982, pp. 32-36

Bill Marvel, "Critic's Choice," *Dallas Times
Herald,* April 9, 1982

James Mills, "Steel Sculpture Exhibit Has
Built-in Audience," *The Denver Post,* Sunday,
September 19, 1982, p. 9 R

Carole Mazur, "Artists' Relationship Enhances
Success," *Albuquerque Journal,* April 10, 1983,
pp. D-1, 2

Susan Zwinger, "Santa Fe Comes to Scottsdale
at the Leslie Levy Gallery," *Artspace,* Spring
1983, p. 83

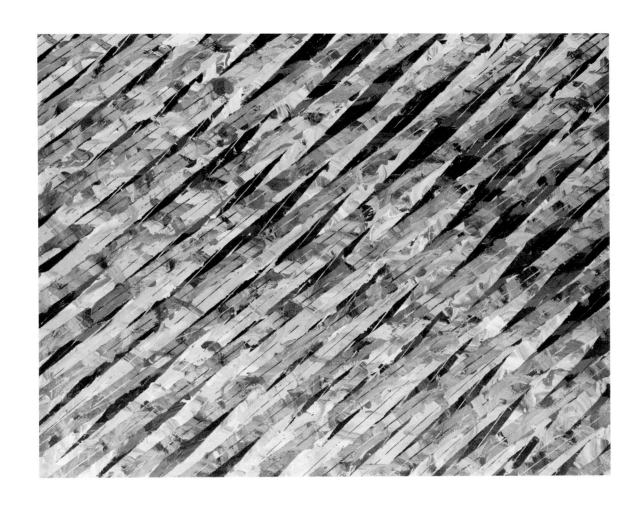

70.
Big Skinny, Blue. 1981
Acrylic on canvas, 60 x 80⅛"
Collection The Solomon R. Guggenheim
Museum, New York

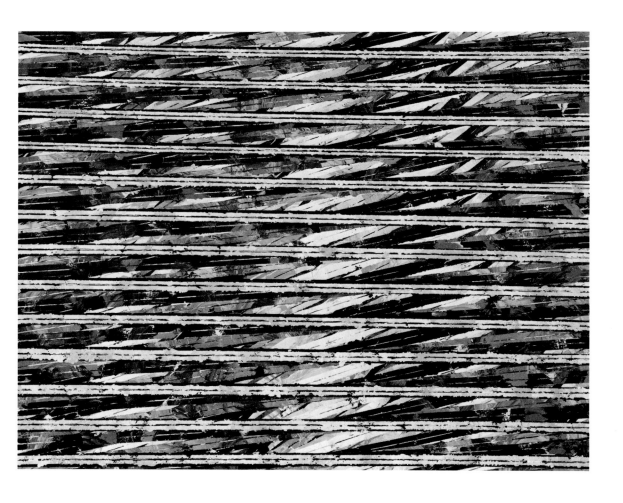

71.
Fast Flicker, Green. 1982
Acrylic on canvas, 60 x 80″
Collection of the artist

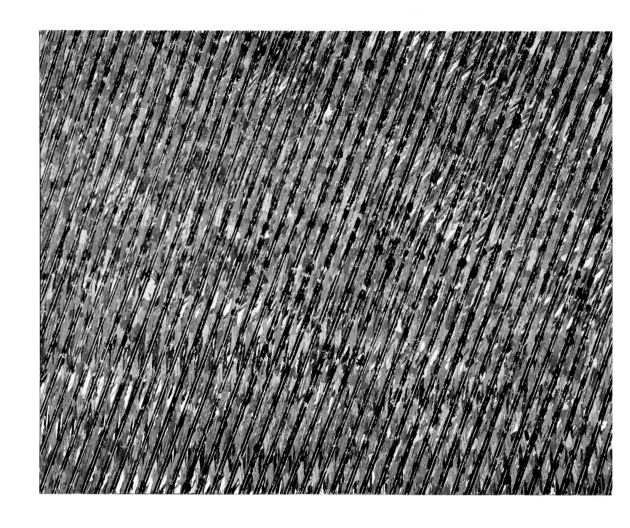

72.
Another Spanish Rain Plane for Jane. 1982
Acrylic on canvas, 75 x 95"
Collection of the artist

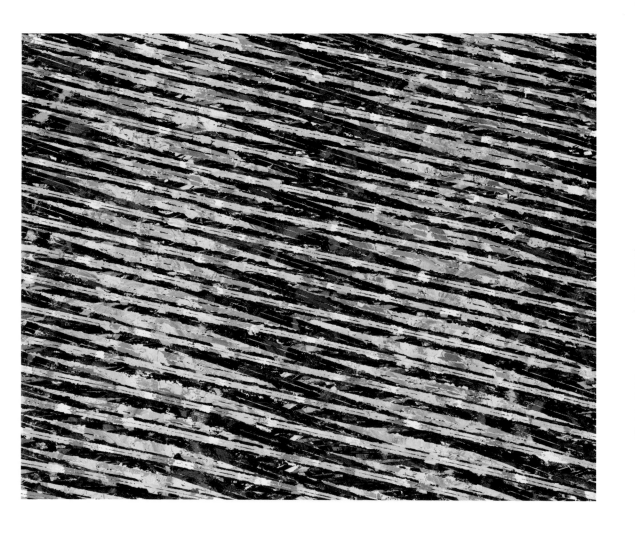

73.
Boo's Night Jewel. 1982
Acrylic on canvas, 75 x 95″
Collection of the artist

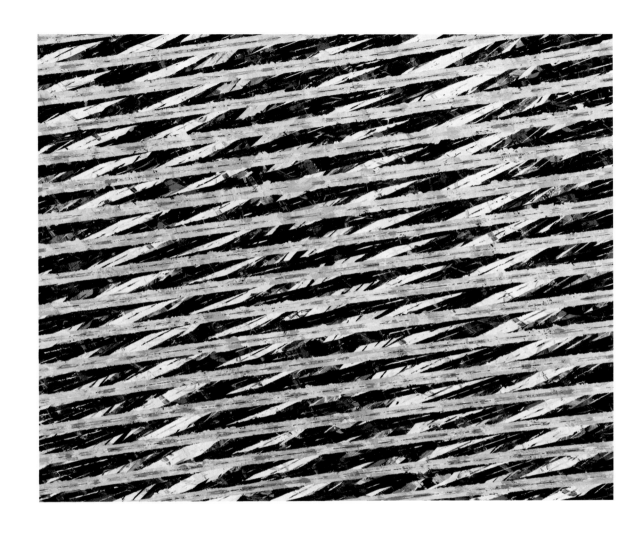

74.
Splintered Interlude for Big Skinny. 1982
Acrylic on canvas, 75 x 95″
Collection of the artist

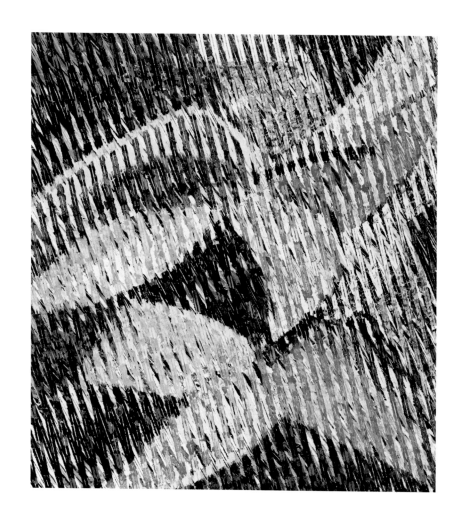

75.
Quilt's Dream. 1982
Acrylic on canvas, 64 x 58″
Collection Arnold and Porter

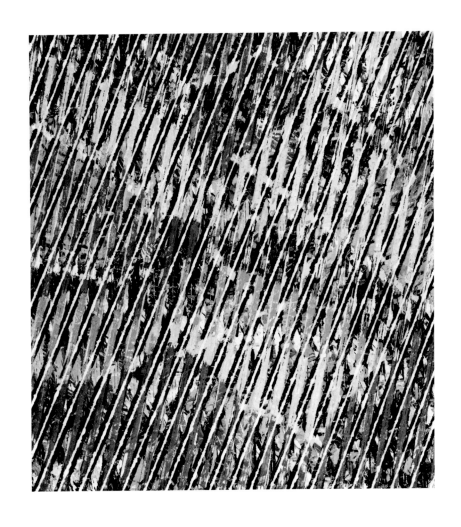

76.
Pulsing Mirage. 1983
Acrylic on canvas, 64 x 58"
Courtesy Sebastian-Moore Gallery, Denver

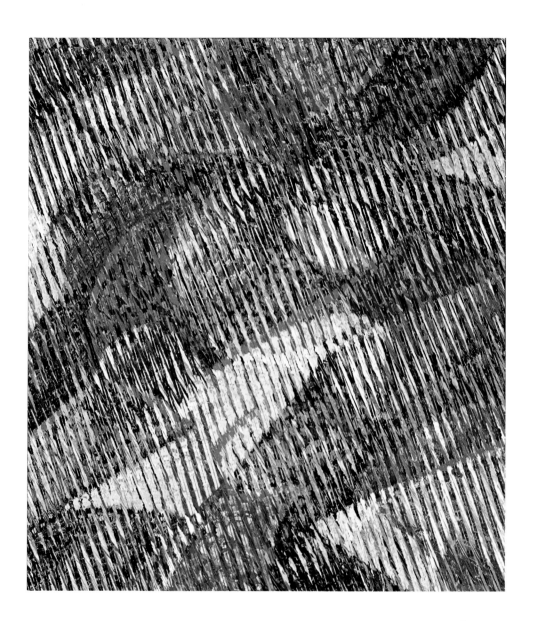

77.
A Fist for Balla. 1983
Acrylic on canvas, 89 x 79″
Collection of the artist

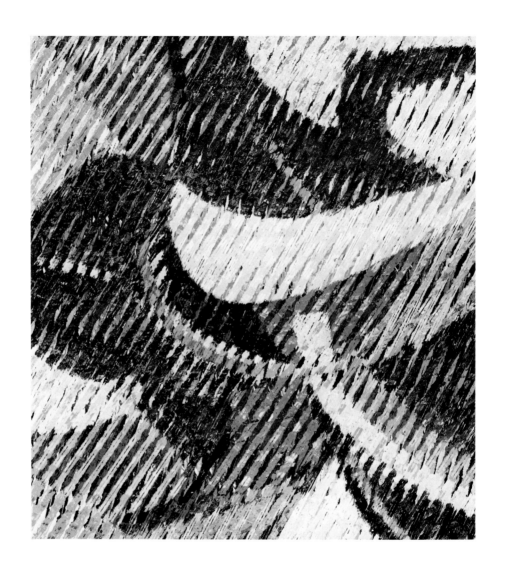

78.
Waiting for a Moment of Silence. 1983
Acrylic on canvas, 64 x 58"
Collection Patsy Catlett, Albuquerque

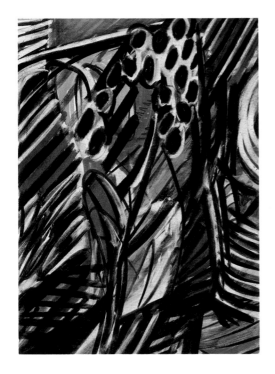

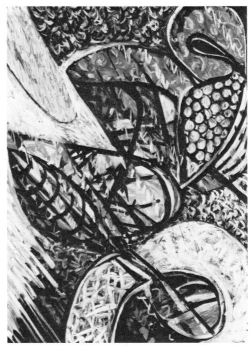

79.
Looking for Wholes #1. 1983
Pastel on paper, 30 x 22″
Private Collection

80.
Looking for Wholes #7. 1983
Pastel on paper, 30 x 22″
Collection of the artist

Tom Lieber

Born in St. Louis, November 5, 1949

University of Illinois, Champaign-Urbana, B.F.A., 1971; M.F.A., 1974

National Endowment for the Arts Grant, 1975

Visiting Artist, Florissant Valley Community College, St. Louis, 1980

Lives and works in Albany, California

Selected Group Exhibitions

St. Louis Art Museum, *Mid-America 4,* June 30-July 30, 1972

Center for the Visual Arts Gallery, Illinois State University at Normal, *Illinois Artists 76,* 1976. Catalogue with text by Tom R. Toperzer

Nancy Lurie Gallery, Chicago, *Nancy Lurie Gallery Artists,* September 16-October 1, 1977

Nancy Lurie Gallery, Chicago, *Reviews and Previews,* January 1-February 5, 1978

San Francisco Museum of Modern Art, *The Aesthetics of Graffiti,* April 28-July 22, 1978. Catalogue with text by Howard J. Pearlstein

William Sawyer Gallery, San Francisco, *22 Landscape Painters,* August 22-September 29, 1978

Louisville School of Art, Anchorage, Kentucky, *3 California Painters,* April 15-May 20, 1979

Palo Alto Cultural Center, *The Controlled Gesture: An Aspect of Bay Area Abstraction,* March 9-April 27, 1980

Nancy Lurie Gallery, Chicago, *Reviews and Previews,* 1980

Nancy Lurie Gallery, Chicago, July 2-August 15, 1981

Joseph Chowning Gallery, San Francisco, July 11-August 6, 1981

Art Center College of Design, Pasadena, *Recent Acquisitions: Selections from the Robert Rowan Collection,* March 21-April 10, 1982

San Francisco Museum of Modern Art, *Fresh Paint: 15 California Painters,* June 17-August 15, 1982. Catalogue with text by George W. Neubert

John Berggruen Gallery, San Francisco, *Selected Acquisitions,* September 15-October 16, 1982

Art Gallery, California State University, Northridge, *New Bay Area Painting and Sculpture,* October 25-November 24, 1982. Catalogue with text by Christopher Brown and Judith Dunham. Traveled to San Francisco Art Institute, December 7, 1982-January 7, 1983

John Berggruen Gallery, San Francisco, April 6-May 7, 1983

Selected One-Man Exhibitions

Levis Faculty Center, University of Illinois, Champaign-Urbana, March 3-April 1, 1974

Michael Wyman Gallery, Chicago, December 3, 1974-January 4, 1975

Michael Wyman Gallery, Chicago, April 5-May 10, 1975

William Sawyer Gallery, San Francisco, August 2-20, 1976

William Sawyer Gallery, San Francisco, November 22-December 9, 1977

Nancy Lurie Gallery, Chicago, March 3-25, 1978

William Sawyer Gallery, San Francisco, March 4-April 4, 1980

Nancy Lurie Gallery, Chicago, September 17-October 15, 1980

Florissant Valley Community College, St. Louis, September 30-October 22, 1980

Kirk De Gooyer Gallery, Los Angeles, August 2-30, 1981

Tom Luttrell Gallery, San Francisco, September 8-October 20, 1981

Kirk De Gooyer Gallery, Los Angeles, September 11-October 9, 1982

The Grayson Gallery, Chicago, September 11-October 13, 1982

Pamela Auchincloss Gallery, Santa Barbara, April 22-May 25, 1983

Selected Bibliography

Alan G. Artner, "Lieber, Nuzum: Two Modes, Mixed and Matched," *Chicago Tribune,* December 29, 1974, p. 14

Alfred Frankenstein, "The Big, Yet Subtle Works of Tom Lieber," *San Francisco Chronicle,* August 14, 1976, p. 34

Robert McDonald, "Tom Lieber: Physicality Finds its Place," *Artweek,* vol. 7, August 14, 1976, p. 4

Robert McDonald, "Tom Lieber's Environmental Paintings," *Artweek,* vol. 8, December 3, 1977, p. 5

Thomas Albright, "A Potpourri of Art: Ideal and Lesser Works," *San Francisco Chronicle,* August 26, 1978, p. 36

Robert McDonald, "Images of the Land," *Artweek,* vol. 7, September 16, 1978, p. 3

Christopher Brown, "Handmade Painting," *Artweek,* vol. 11, March 29, 1980, p. 5

Alan G. Artner, "Tom Lieber," *Chicago Tribune,* October 1, 1980, p. 5

Thomas Albright, "The Emphasis is on Surfaces," *San Francisco Chronicle,* March 15, 1981, p. 38

Robert L. Pincus, "Summertime at Art Galleries," *Los Angeles Times,* August 20, 1981, part VI, p. 13

Charles Shere, "Today," *Oakland Tribune,* October 1, 1981, p. C 5

Al Morch, "15 California Painters," *San Francisco Examiner,* June 21, 1982, p. E 5

Suzaan Boettger, "Fresh Paint, New Fingerprints," *San Francisco Chronicle,* June 27, 1982, pp. 15-16

Alan G. Artner, "Art Galleries," *Chicago Tribune,* September 17, 1982, weekend section

Sheldon Figstein, "Downtown," *Los Angeles Times,* September 24, 1982, part VI, p. 9

Thomas Albright, "Fresh Paint," *Art News,* vol. 81, September 1982, pp. 114-119

Sheldon Figstein, "Energy into Image," *Artweek,* vol. 13, October 1982, p. 6

Mac McCloud, "Tom Lieber," *Images and Issues,* vol. 3, January/February 1983, pp. 60-61

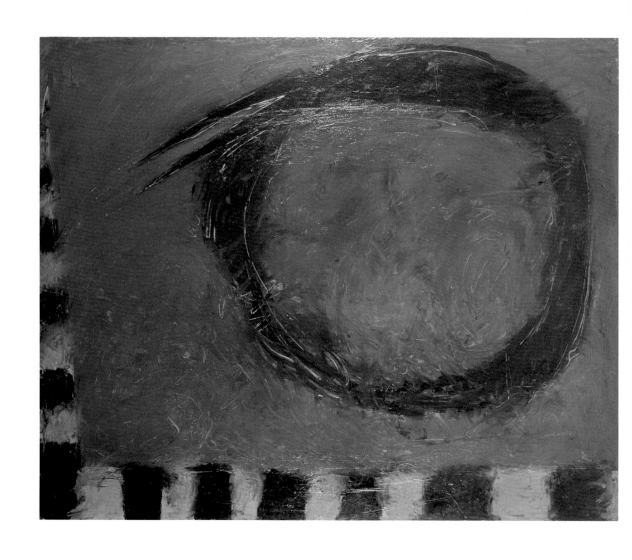

81.
Rhyme's Reason. 1981
Acrylic on canvas, 78 x 96″

Collection of the artist; courtesy John
Berggruen Gallery, San Francisco

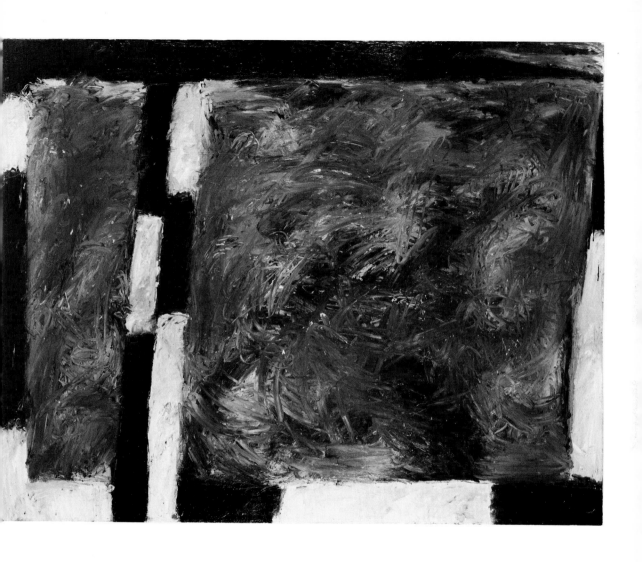

82.
Still of the Night. 1981
Acrylic on canvas, 84 x 108″
Collection of the artist; courtesy John
Berggruen Gallery, San Francisco

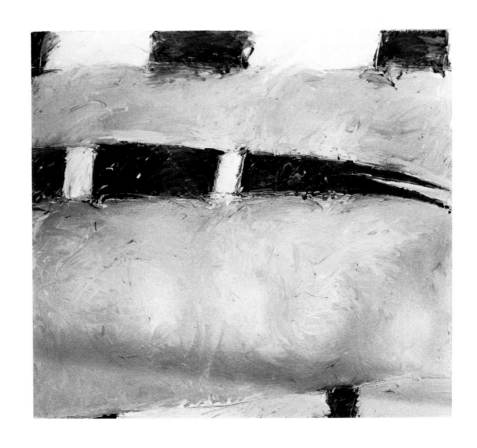

83.
Easter. 1981
Acrylic on canvas, 68 x 76½″
Courtesy John Berggruen Gallery, San
Francisco

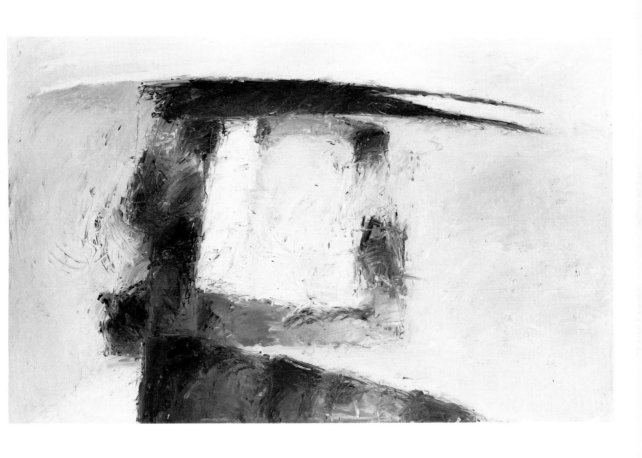

84.
Struggle. 1982
Acrylic on canvas, 72 x 108″
Courtesy John Berggruen Gallery, San
Francisco

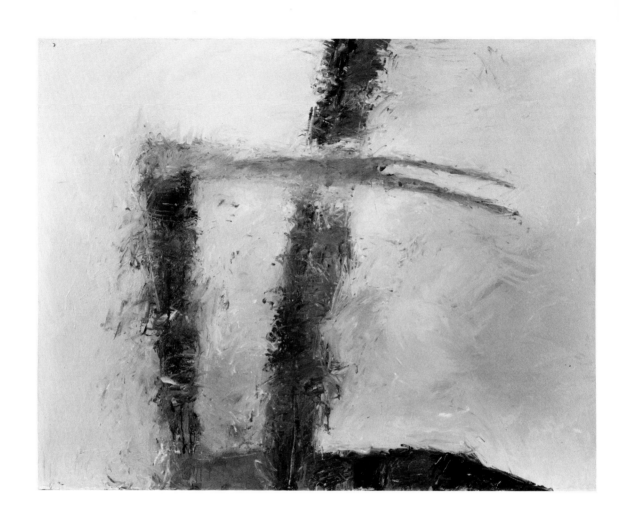

85.
Probe I. 1982
Acrylic on canvas, 71¼ x 92″
**Courtesy John Berggruen Gallery, San
Francisco**

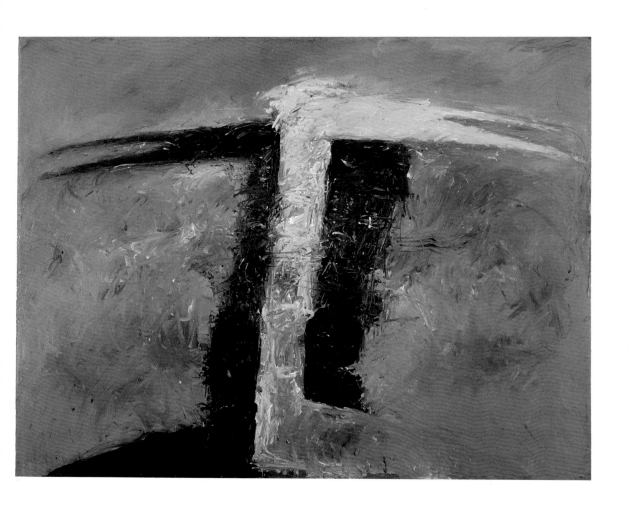

86.
Two Attentions. 1983
Acrylic on canvas, 72 x 96″
Courtesy John Berggruen Gallery, San
Francisco

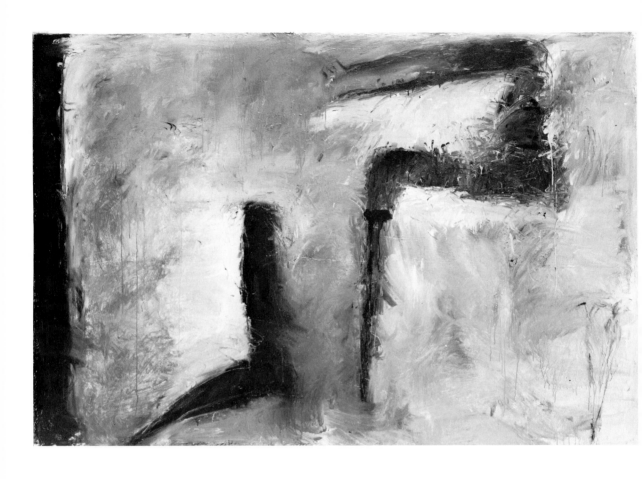

87.
Rites of Passage. 1983
Acrylic on canvas, 72 x 108″

Collection Rufus Williams, San Francisco;
courtesy John Berggruen Gallery, San
Francisco

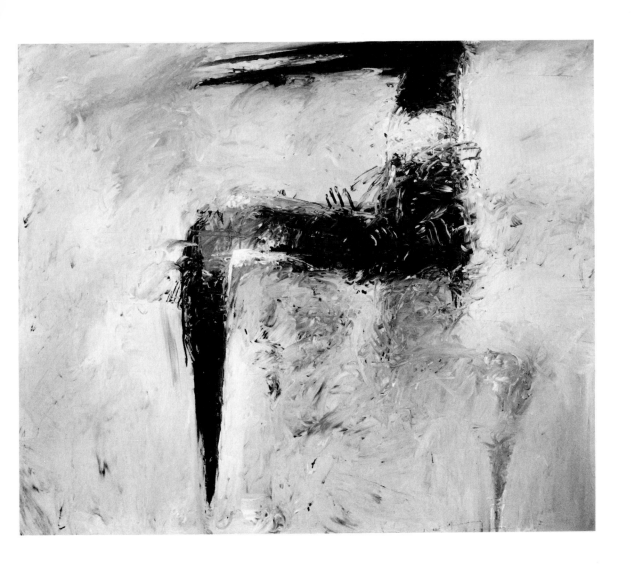

88.
Thief to Attention. 1983
Acrylic on canvas, 80 x 96"
Collection Robert A. Rowan

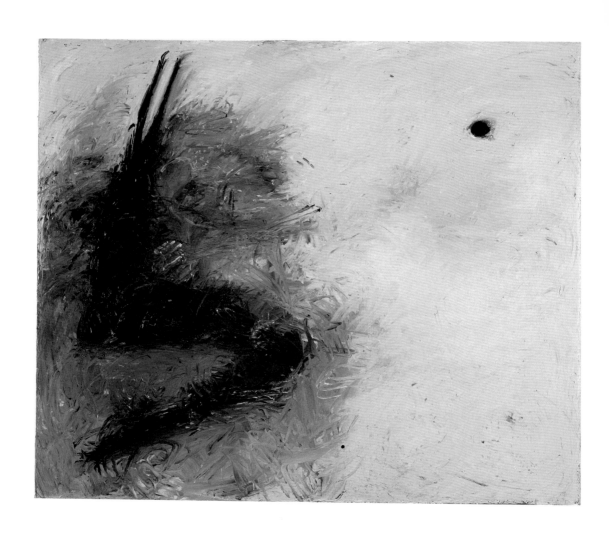

89.
Focus II. 1983
Acrylic on canvas, 72 x 84″

Collection Gretchen and Ron Weiss, Oakland,
California; courtesy John Berggruen Gallery,
San Francisco

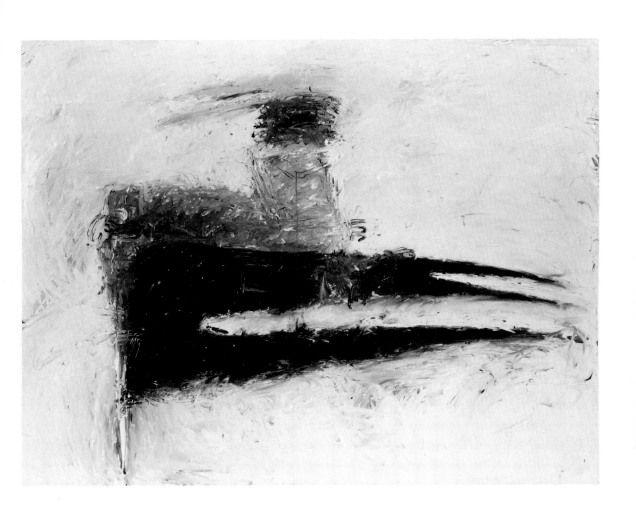

90.
Transferage. 1983
Acrylic on canvas, 72 x 96″
Private Collection; courtesy John Berggruen
Gallery, San Francisco

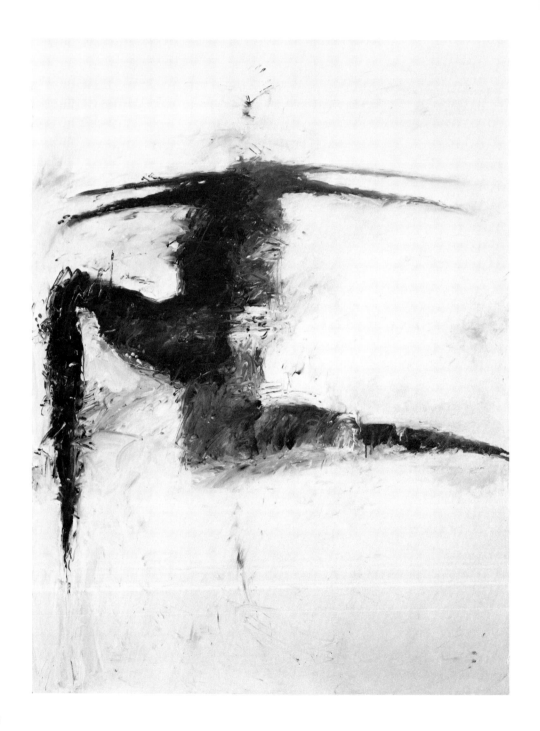

91.
Back to Back. 1983
Acrylic on canvas, 96 x 72″

Courtesy John Berggruen Gallery, San
Francisco

Michael C. McMillen

Born in Los Angeles, April 6, 1946

San Fernando Valley State College, California, B.A., 1969

University of California, Los Angeles, M.A., 1972; M.F.A., 1973

Art Council Fellowship, University of California, Los Angeles, 1972

Australia Council Travel Grant, Sydney, in conjunction with *Biennale of Sydney,* 1976

New Talent Award, Contemporary Art Council, Los Angeles County Museum of Art, 1978

Artist's Fellowship, National Endowment for the Arts, 1978

Lives and works in Santa Monica

Selected Group Exhibitions

Los Angeles Institute of Contemporary Art, *Collage and Assemblage,* March 29-May 9, 1975

San Francisco Art Institute, *Eight Artists from Los Angeles,* September 20-November 2, 1975

Newport Harbor Art Museum, Newport Beach, California, *Sounds: Audio-Visual Environments by Four L.A. Artists,* December 8, 1975-January 11, 1976. Catalogue

Los Angeles Institute of Contemporary Art, *Imagination,* April 19-May 7, 1976

Art Gallery of New South Wales, Sydney, *Biennale of Sydney,* November 13-December 19, 1976. Catalogue

Fine Arts Gallery, California State University, Northridge, *We All Were Here,* October 3-23, 1977. Catalogue with text by Joanne Julian

California State University, Los Angeles, *Miniature,* October 3-November 10, 1977. Catalogue with text by Sandy Balatore

Fort Worth Art Museum, *Los Angeles in the Seventies,* October 9-November 20, 1977. Catalogue with text by Marge Goldwater.

Traveled to Joslyn Art Museum, Omaha, March 1-April 15, 1979

Los Angeles Institute of Contemporary Art, *Art Words and Bookworks,* February 28-March 30, 1978. Traveled to Artists Space, New York, June 10-30, 1978; Herron School of Art, Indianapolis, September 15-29; New Orleans Contemporary Art Center, October-November; Ewing and George Paton Galleries, Melbourne, Australia; Institute of Modern Art, Brisbane; Queen Victoria Museum and Art Gallery, Launceston, Australia; Experimental Art Foundation, Adelaide, Australia; Undercroft Gallery, Perth; Geelong Art Gallery, The Sculpture Center, Sydney

Los Angeles Institute of Contemporary Art, *100+ Current Directions in Southern California Art,* April 5-14, 1978

Otis Art Institute, Los Angeles, *Beyond Realism,* September 14-October 15, 1978

Arco Center for Visual Art, Los Angeles, *Eccentric Los Angeles Art,* November 14-December 30, 1978

Los Angeles Municipal Art Gallery, *Other Things that Artists Make,* December 5, 1978-January 7, 1979

Walker Art Center, Minneapolis, *Eight Artists: The Elusive Image,* September 30-November 18, 1979

Los Angeles Institute of Contemporary Art, *Tableau,* February 2-March 8, 1980

San Diego Art Museum, *Sculpture in California 1975-80,* May 18-July 6, 1980. Catalogue with text by Richard Armstrong

Los Angeles Municipal Art Gallery, *In a Major and Minor Scale,* May 28-June 29, 1980

Middendorf/Lane Gallery, Washington, D.C., *Tableau—An American Selection,* September 2-October 11, 1980. Catalogue

Mount St. Mary's College Fine Arts Gallery,

Los Angeles, *Architectural Sculpture,* September 29-November 2, 1980. Catalogue with text by Craig Hodgetts

Los Angeles County Museum of Art, *Art in Los Angeles—The Museum as Site: Sixteen Projects,* July 21-October 4, 1981. Catalogue with text by Stephanie Barron

California State College, San Bernardino, *Locations,* October 9-November 4, 1981. Catalogue with text by Don Woodford

Art Gallery of New South Wales, Sydney, *Patrick White's Choice,* December 22, 1981-January 31, 1982

The Oakland Museum, California, *100 Years of California Sculpture,* August 7-October 17, 1982. Catalogue

The Corcoran Gallery of Art, Washington, D.C., *The Second Western States Exhibition and The 38th Corcoran Biennial Exhibition of American Painting,* February 3-April 4, 1983. Catalogue with text by Clair List. Traveling to Lakeview Museum of Arts and Sciences, Peoria, Illinois, May 6-August 31; The Scottsdale Center for the Arts, October 8-November 20; The Albuquerque Museum, December 18-March 4, 1984; San Francisco Museum of Modern Art, August 30-November 11

Los Angeles County Museum of Art, *Young Talent Awards: 1963-1983,* July 14-September 18, 1983. Catalogue with texts by Maurice Tuchman and Anne Edgerton

Selected One-Man Exhibitions

312 Westminster (storefront gallery), Venice, California, *The Traveling Mystery Museum,* June 16-26, 1973

Los Angeles County Museum of Art, *Inner City,* November 1-December 31, 1977. Traveled to Whitney Museum of American Art, New York, October 3-December 3, 1978

Cerro Coso College, Ridgecrest, California, *Ray Cathode's Garden,* April 8-28, 1978

Art Gallery of New South Wales, Sydney, *Project 29: Michael McMillen,* March 8-April 13, 1980. Catalogue with text by Bernice L. Murphy

Macquarie Galleries, Sydney, April 23-May 19, 1980

Asher/Faure, Los Angeles, October 25-November 22, 1980

Pittsburgh Center for the Arts, *The Floating Diner,* January 4-25, 1981

Macquarie Galleries, Sydney, March 10-27, 1982

Asher/Faure, Los Angeles, October 16-November 13, 1982

Selected Performances

Los Angeles Institute of Contemporary Art Gallery, *The Living Brain of Picasso,* January 1975

California State University, Northridge, *Mr. Potatohead's Alpha Waves,* May 13, 1975

Selected Bibliography

By the artist:

"True Confessions," *LAICA Journal,* no. 8, November-December 1975, pp. 21-22

"Special FX Breakdown," *LAICA Journal,* no. 14, April-May 1977, pp. 37-39

On the artist:

William Wilson, "Sculpture that's Hard to Put Down," *Los Angeles Times,* February 18, 1974, p. 8

Walter Gabrielson, "The Ironic Los Angeles Artist," *LAICA Journal,* no. 12, October-November 1976, p. 25

Louise Lewis, "Michael McMillen—An Environment of Understatement," *Artweek,* vol. 8, November 26, 1977, p. 3

William Wilson, "Miniatures at LACMA: Touchstone of the 70's," *Los Angeles Times,* November 27, 1977, calendar section, p. 110

Janet Kutner, "Los Angeles in the Seventies," *Art News,* vol. 76, December 1977, pp. 104-106

Christopher Knight, "Some Recent Art and an Architectural Analogue," *LAICA Journal,* no. 17, January-February 1978, pp. 50-54

Melinda Wortz, "Inner City of the Mind," *Art News,* vol. 77, February 1978, pp. 106-108

Barbara Radice, "L'Arte è una Realtà in Scala 1/100," *Modo,* vol. 2, April 1978, pp. 67-68

Christopher Brown, "Los Angeles Oddities," *Artweek,* vol. 9, June 17, 1978, p. 3

Peter Frank, "Inner City," *The Village Voice,* November 13, 1978, p. 113

Barbara Rose, "Miniature Worlds: Archeology as Art," *Vogue Magazine,* vol. 168, November 1978, p. 64

Christina J. Madans, "Outside the L.A. Mainstream," *Artweek,* vol. 9, December 9, 1978, p. 1

Deborah Perlberg, "Michael McMillen, Whitney Museum," *Artforum,* vol. XVI, December 1978, pp. 66-67

Richard Whelan, "Michael McMillen at the Whitney," *Art in America,* vol. 67, May-June 1979, p. 134

Christopher Knight, *Design Quarterly,* no. 111/112, 1979, pp. 41-45

Louise Lewis, "Experience in Tableaux," *Artweek,* vol. 11, February 23, 1980, p. 5

Susanna Short, "Lilliputian Illusions," *The National Times* (Australia), May 4, 1980, p. 55

Michael Blaine, "Architectural Spoof and Satire," *Artweek,* vol. 11, October 18, 1980, p. 20

Christopher Knight, "Behold: A Power Plant or Frankenstein's Lab?" *Los Angeles Herald Examiner,* October 30, 1980, section C, pp. 1-2

Michael Blaine, "Personal Attitudes Revealed," *Artweek,* vol. 11, November 15, 1980, p. 6

Barbara Radice, "Apocalissi Pubbliche Private Solitarie," *Modo,* no. 38, April 1981, pp. 78-79

Christopher Knight, "The Fun of Tickling our Art Bone," *Los Angeles Herald Examiner,* July 12, 1981, p. E 4

Christopher Knight, "Site Seeing at the County Museum," *Los Angeles Herald Examiner,* July 26, 1981, pp. E 2-3

Mark Stevens, "California Dreamers," *Newsweek,* August 17, 1981, pp. 78-79

Peter Schjeldahl, "Spanning Time Zones," *The Village Voice,* September 2, 1981, p. 70

Christopher Knight, *Arts and Architecture,* vol. 1, Fall 1981, pp. 22-23

Melinda Wortz, "17 Artists and 16 Projects in Los Angeles," *Art News,* vol. 80, November 1981, pp. 161-165

3 Years On: A Selection of Acquisitions 1978-1981, Art Gallery of New South Wales, Sydney, 1981, pp. 42, 56

Peter Plagens, "Site Wars," *Art in America,* vol. 70, January 1982, pp. 90-98

Sandra McGrath, "Lilliputian View of Two Worlds," *The Australian,* March 1982

Barbara Radice, "Art in Los Angeles," *Modo,* no. 47, March 1982, pp. 72-75

Howard Singerman, "Art in Los Angeles," *Artforum,* vol. XX, March 1982, pp. 75-77

William Wilson, "Art and Survival," *Los Angeles Times,* May 21, 1982, part VI, p. 10

Christopher Knight, "An Anti-Nuclear-War Art Exhibit that all but Self-Destroys," *Los Angeles Herald Examiner,* May 23, 1982, p. E 5

William Wilson, "The Galleries," *Los Angeles Times,* October 22, 1982, part VI, p. 67

Ruth Weisberg, "Fragmented Histories," *Art-week,* vol. 13, November 6, 1982, p. 16

Peter Clothier, "Michael C. McMillen at Asher Faure," *Art in America,* vol. 71, January 1983, pp. 127-128

Paul Richard, "The Range of the West—The Corcoran Biennial Goes Bold and Brisk," *The Washington Post,* February 2, 1983

Susan C. Larsen, "Michael C. McMillen, Asher-Faure Gallery," *Artforum,* vol. XXI, February 1983, pp. 85-86

Film

Peter Drummond, *Inner City by West Coast Artist Michael McMillen*, Victoria, Australia, 1977. Color, 16mm, 7 minutes

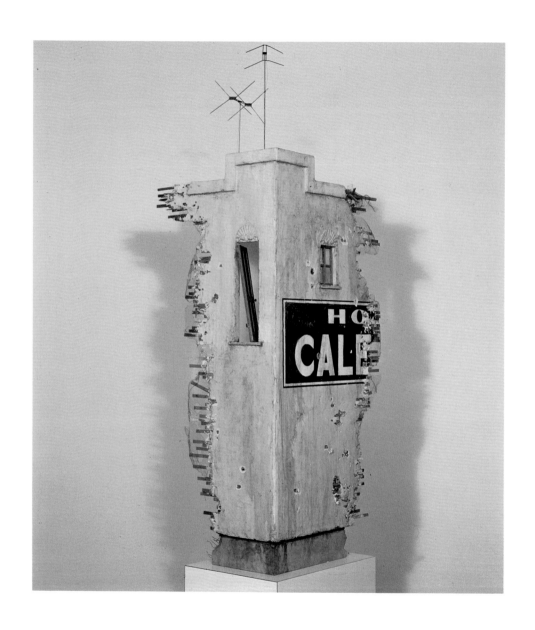

92.
The Caledonia. 1980
Mixed media construction, 49 x 19 x 17"
Collection Aviva and Carl Covitz

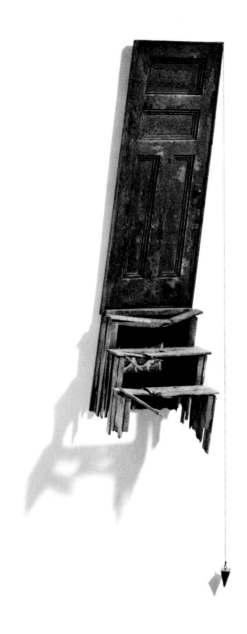

93.
Oriental Magician (Red). 1980
Mixed media construction, 33 x 6 x 2″
Collection Mr. and Mrs. Sidney Kibrick

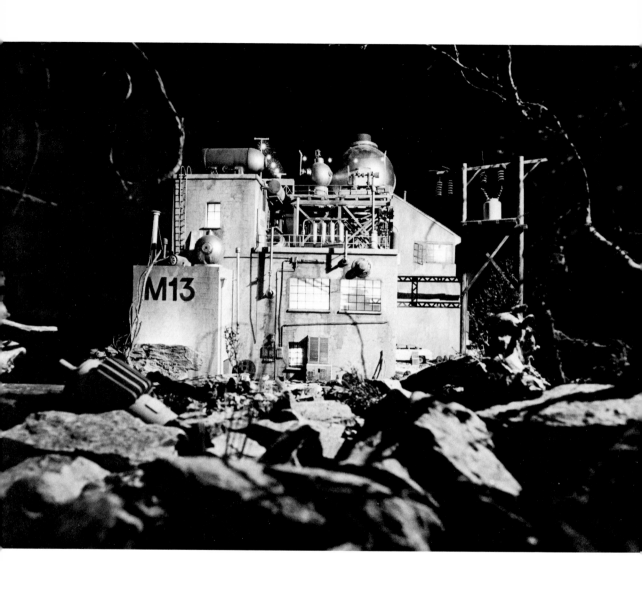

94.
M 13. 1980
Installation for exhibition, *Architectural Sculpture,* Mt. St. Mary's College, Fine Arts Gallery, Los Angeles
10 x 14 x 31′

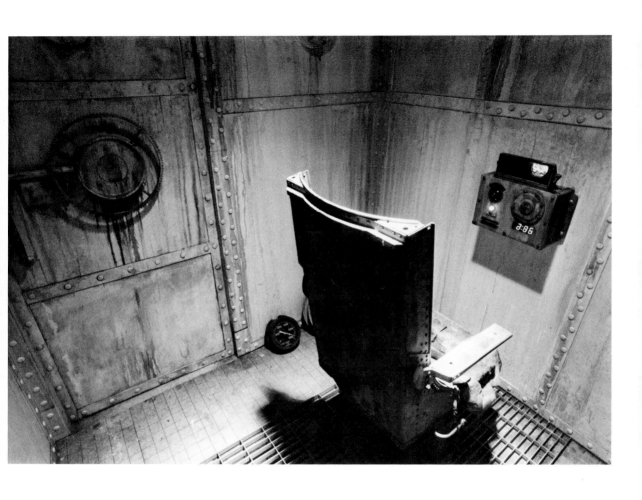

94.
M 13 (detail).

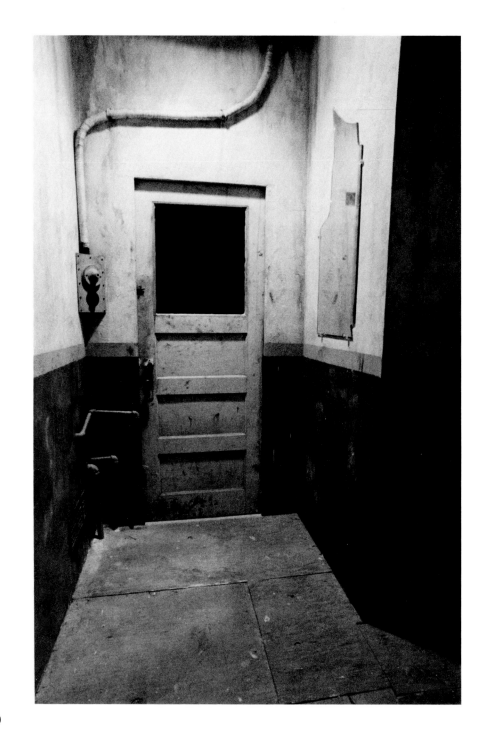

94.
M 13 (deta

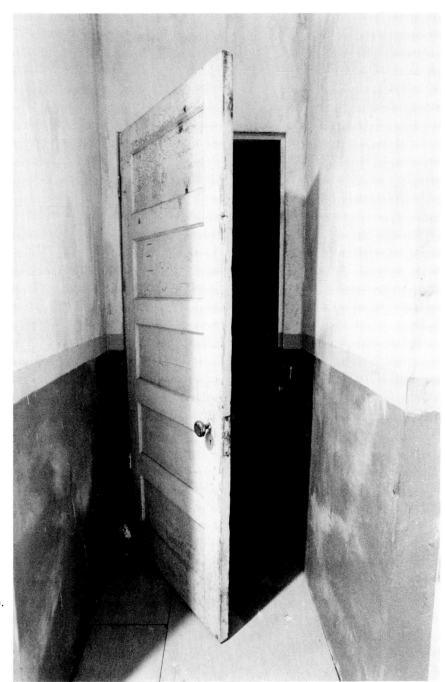

94.
M 13 (detail).

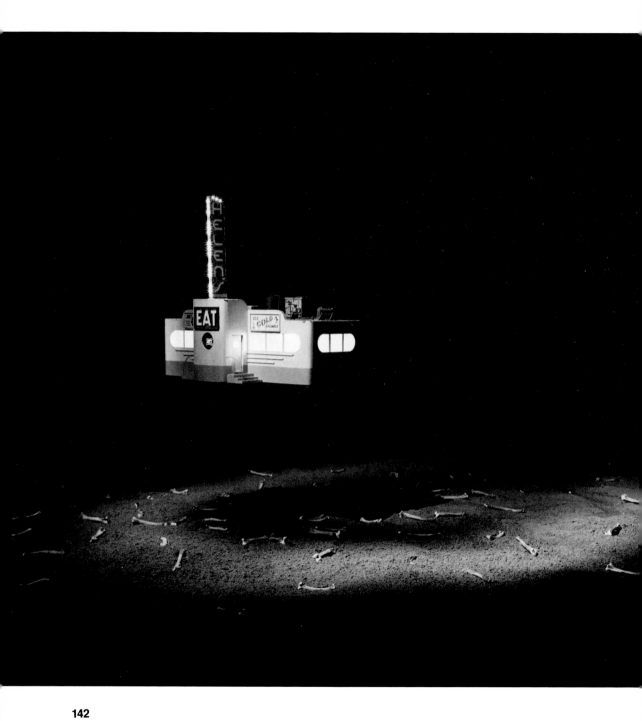

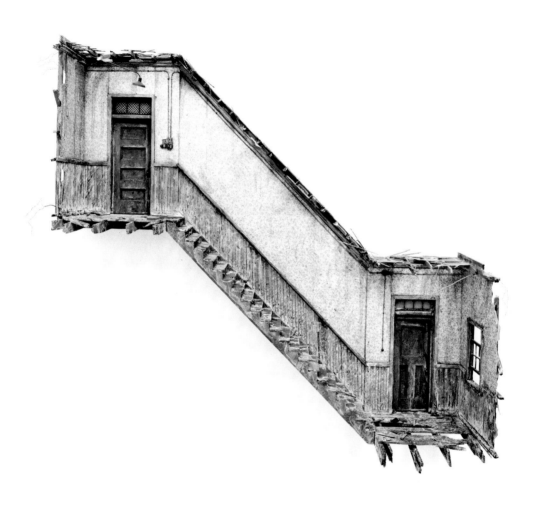

95.
The Floating Diner. 1980
Installation at Pittsburgh Center of the Arts

96.
China Landing. 1981
Mixed media construction, 27 x 30 x 8″
Collection Robert H. Halff, Beverly Hills

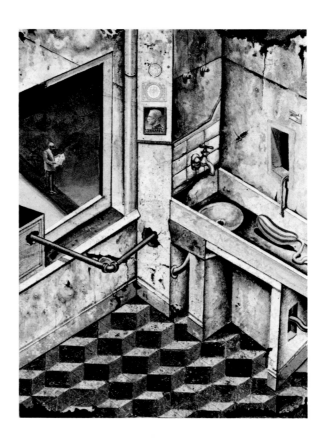

97.
Locus Solus. 1982
Oil on board with collaged elements,
15¾ x 11¼″
Private Collection

98.
Dancing Door. 1982
Mixed media construction, 19 x 15 x 10″
Courtesy Asher/Faure, Los Angeles

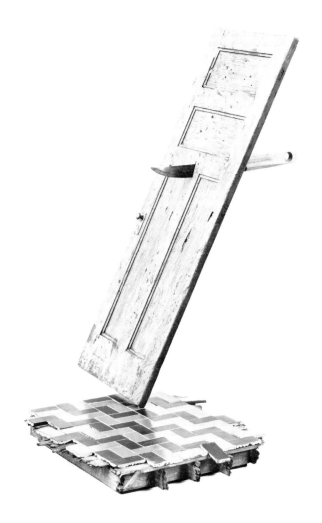

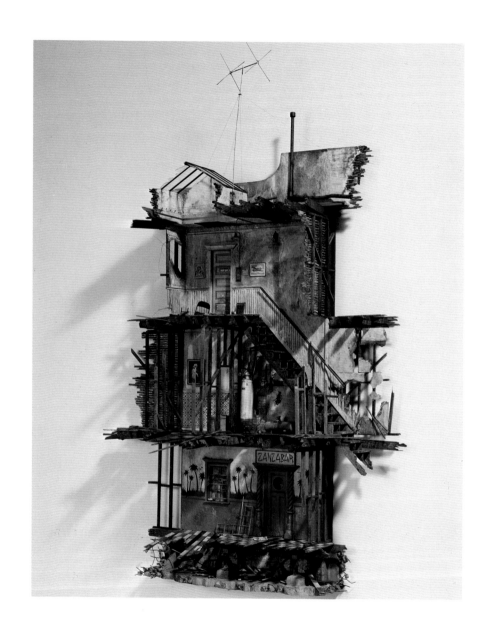

99.
The Zanzabar. 1982
Mixed media construction, 50 x 33 x 10″
Collection William Bartman, Los Angeles

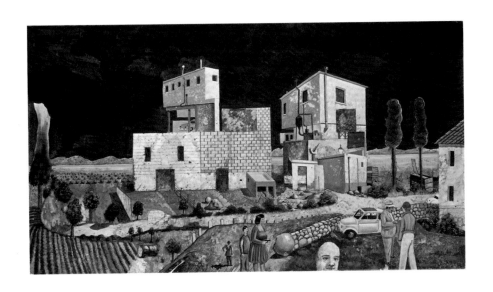

100.
Italian Landscape. 1982
Oil on panel, 13¾ x 21¾″
Collection James Butler, Los Angeles

Nic Nicosia

Born in Dallas, June 24, 1951

North Texas State University, Denton, B.A., 1974

North Texas State University and University of Houston, graduate studies, 1979-80

Lives and works in Dallas

Selected Group Exhibitions

North Texas State University, Denton, *Voertman Show,* April 1-10, 1980

Laguna Gloria Art Museum, Austin, *Texas Only,* August 23-September 14, 1980

The Print Club, Philadelphia, *The Print Club's 56th Annual International Competition of Prints and Photographs,* December 2, 1980-January 3, 1981

Washington Project for the Arts, Washington, D.C., *Texas Photo Sampler,* January 6-31, 1981. Catalogue with text by Al Nodal. Traveled to Camerawork, San Francisco, October 13-November 14, 1981

Contemporary Arts Museum, Houston, *The New Photography,* January 17-February 22, 1981. Catalogue with texts by Linda Cathcart and Marti Mayo

2 Houston Center, Houston, *The Road Show,* March 5-April 3, 1981. Catalogue

Longview Museum and Arts Center, Texas, *Invitational '81,* March 7-April 24, 1981

Central Washington University, Ellensburg, *New Photographics '81,* April 6-May 1, 1981

500 Exposition Gallery, Dallas, *Photoworks: Steve Dennie/Nic Nicosia,* April 11-May 9, 1981

Delahunty Gallery, Dallas, *Staged Shots,* April 11-May 6, 1981

80 Washington Square East Galleries, New York University, New York, *American Vision,* October 13-November 6, 1981

Galveston Arts Center Gallery, Texas, *Steve Dennie/Nic Nicosia,* November 6-November 29, 1981

Hallwalls and C.E.P.A. Gallery, Buffalo, February 7-27, 1982

Texas Gallery, Houston, *Henrich, Nicosia, Williams,* May 28-June 30, 1982

Delahunty Gallery, New York, *Beyond Photography: The Fabricated Image,* June 8-July 31, 1982

Magnuson-Lee Gallery, Boston, *Fabricated Images/Color Photography,* September 11-October 20, 1982

Graduate School of Design, Harvard University, Cambridge, Massachusetts, *Space Framed I,* September-October 1981

Musée National d'Art Moderne, Centre Georges Pompidou, Paris, *Image Fabriqué,* February 10-March 13, 1983. Catalogue with text by Alain Sayag

Laguna Gloria Art Museum, Austin, Texas, *Touch with Your Eyes, Feel with Your Mind: Surfaces in Contemporary Art,* February 20-March 27, 1983

Delahunty Gallery, New York, *Group Exhibition,* March 15-April 6, 1983

Whitney Museum of American Art, New York, *Whitney Biennial,* March 23-May 29, 1983. Catalogue

New Orleans Museum of Art, *The New Orleans Triennial,* April 8-May 22, 1983. Catalogue with text by Linda Cathcart

Castelli Graphics, New York, *Nimslo 3 Dimensional Photography,* April 12-May 4, 1983

North Texas State University, Art Department Gallery, Denton, *Making Photographs: Six Alternatives,* August 29-September 16, 1983

Selected One-Man Exhibitions

Brown Lupton Gallery, Texas Christian University, Fort Worth, *Nic Nicosia—Photographs,* October 12-30, 1981

Artists Space, New York, *Nic Nicosia,* November 16-December 4, 1982

Delahunty Gallery, Dallas, *Nic Nicosia / Domestic Dramas,* December 18, 1982-February 2, 1983

Light Song Gallery, University of Arizona, Tucson, *Nic Nicosia,* March 16-April 8, 1983

Selected Bibliography

Judy Gossitt Anderton, "Nic Nicosia," *Dallas Photo Magazine,* vol. 1, October 1978, pp. 16-17

Susan Kalil, "Photographic Cross-currents," *Artweek,* vol. 12, February 7, 1981, p. 1

Bill Marvel, "League Lobbies Quality Show," *Dallas Times Herald,* March 21, 1981, p. 1 C

Charles Dee Mitchell, "Pretty Pictures Give Way to Fabricated Reality," *Dallas Observer,* April 2-15, 1981, p. 13

Joan Murry, "New Photographics—An Esthetic Barometer," *Artweek,* vol. 12, April 18, 1981, p. 1

Janet Kutner, "Photographers Call the Shots with Fantasy," *The Dallas Morning News,* May 2, 1981, p. 1 C

Robert Raczka, "Stephen Dennie and Nic Nicosia," *Artspace Quarterly,* vol. 5, Fall 1981, pp. 62-63

Anthony Bannon, "Big New Colorful Photographs," *The Buffalo News,* February 7, 1982, p. G 1

Anthony Bannon, "Noble Images Used To Transform Magazine Photographs into Art," *The Buffalo Evening News,* February 16, 1982, p. G 1

Richard Huntington, "Neutrality of Camera Evidenced in Two," *Buffalo Courier-Express,* February 21, 1982

Susan Kalil, "Rooted in Ambiguity," *Artweek,* vol. 15, June 19, 1982, p. 14

Andy Grundberg, "Explaining the Improbable," *The New York Times,* July 11, 1982, p. H 1

Andy Grundberg, "In Today's Photography, Imitation Isn't Always Flattery," *The New York Times,* November 14, 1982, p. H 39

Charles Dee Mitchell, "Nicosia's Domestic Dramas," *Dallas Observer,* December 16-29, 1982, p. 15

Janet Kutner, "Is it live or is it Nicosia? Staged sets, sharp wit causes inspired irony," *The Dallas Morning News,* January 27, 1983, p. C 1

Andy Grundberg, "Photography: Biennial Show," *The New York Times,* Friday, April 1, 1983, p. C 23

Roger Green, "Controversy at N.O.M.A.'s Triennial," *Times-Picayune,* April 17, 1983, section 3, pp. 2-3

Susan Kalil, "1983 New Orleans Triennial: An Interview with Guest Curator Linda Cathcart," *Arts Quarterly,* New Orleans Museum of Art, vol. 5, April-June 1983, pp. 1-14

"Camera at Work: Scene Stealers," *Life,* vol. 6, May 1983, pp. 10-11

Andy Grundberg and Carol Squiers, "Family Fables," *Modern Photography,* vol. 47, June 1983, pp. 78-83

Susan Freudenheim, "Nic Nicosia: One Shot Reality," *Texas Home,* July 1983, vol. 7, no. 7, p. 25

Susan Freudenheim, "Nic Nicosia at Delahunty," *Art in America,* vol. 71, Summer 1983, p. 163

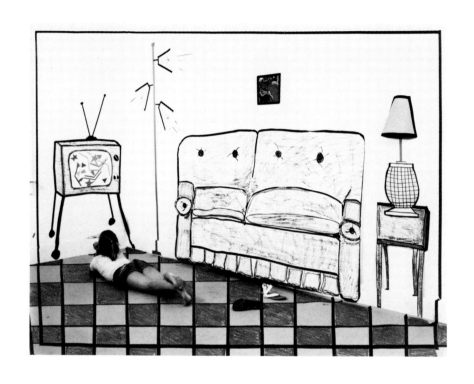

101.
Coloring Book #2. 1981
Ektacolor print, 30 x 40″
1/8
Collection of the artist; courtesy Delahunty
Gallery, Dallas and New York

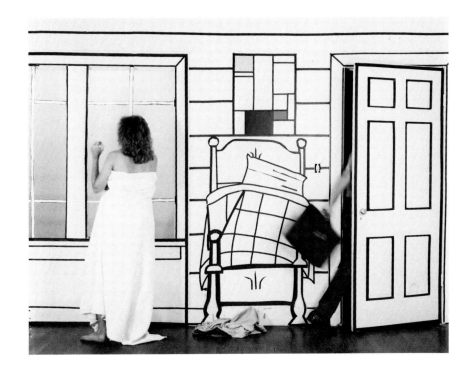

102.
Coloring Book #3. 1981
Ektacolor print, 30 x 40″
1/8
Collection of the artist; courtesy Delahunty
Gallery, Dallas and New York

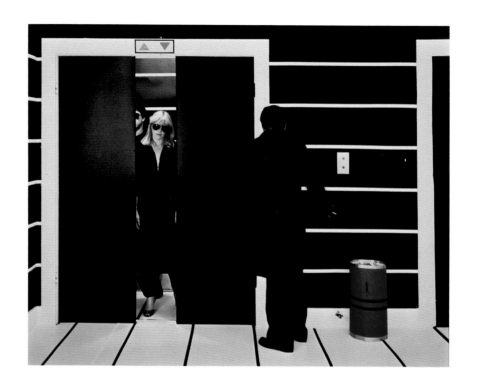

103.
Elevator #1. 1981
Ektacolor print, 30 x 40″
1/3
Collection of the artist; courtesy Delahunty
Gallery, Dallas and New York

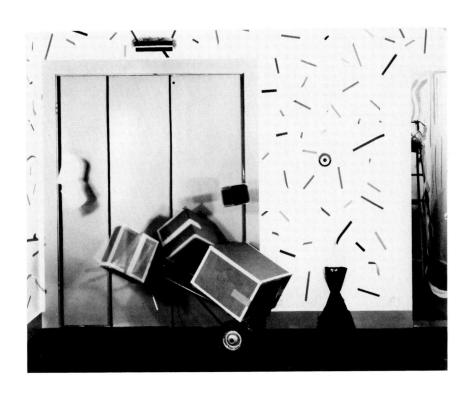

104.
Elevator #2. 1981
Ektacolor print, 30 x 40"
1/8 of second edition
Collection of the artist; courtesy Delahunty
Gallery, Dallas and New York

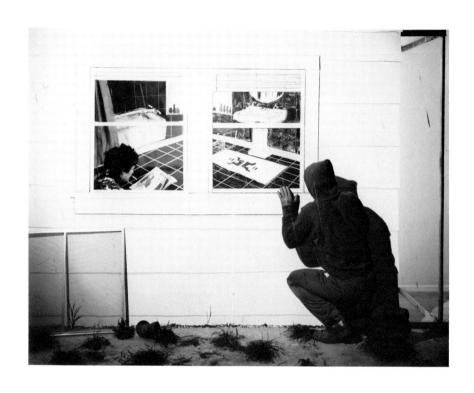

105.
Surprise. 1981
Ektacolor print, 30 x 40″
1/8
Collection of the artist; courtesy Delahunty
Gallery, Dallas and New York

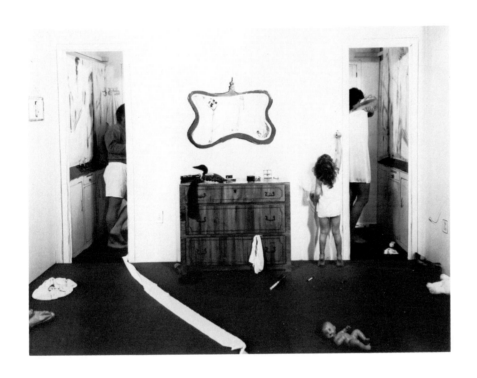

106.
Domestic Drama #1. 1982
Ektacolor print, 30 x 40″
1/8
Collection of the artist; courtesy Delahunty
Gallery, Dallas and New York

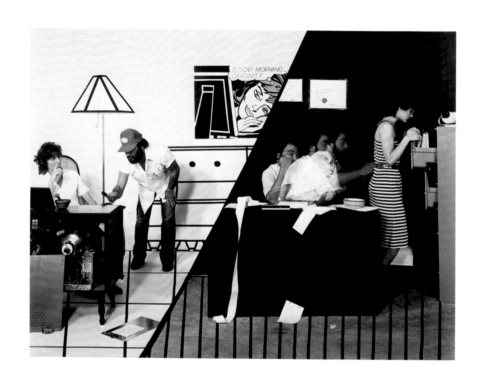

107.
Domestic Drama #2. 1982
Ektacolor print, 30 x 40"
1/10
Collection of the artist; courtesy Delahunty
Gallery, Dallas and New York

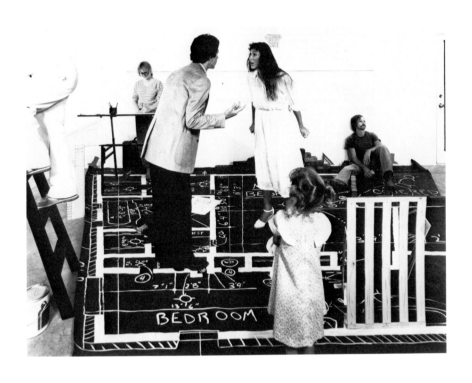

108.
Domestic Drama #4. 1982
Ektacolor print, 30 x 40″
1/10
Collection of the artist; courtesy Delahunty
Gallery, Dallas and New York

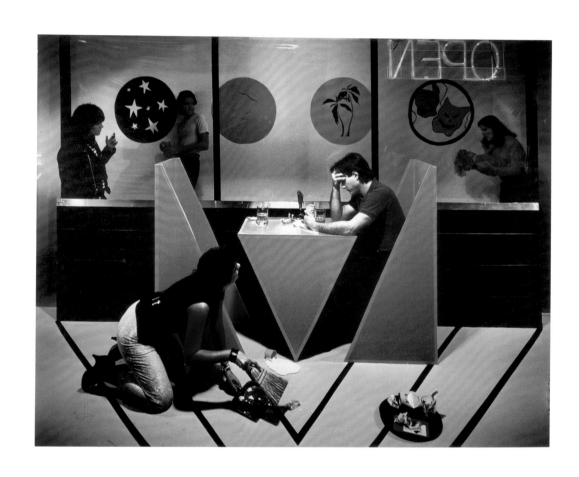

109.
Domestic Drama #5. 1982
Cibachrome print, 40 x 60"
1/15
Collection of the artist; courtesy Delahunty
Gallery, Dallas and New York

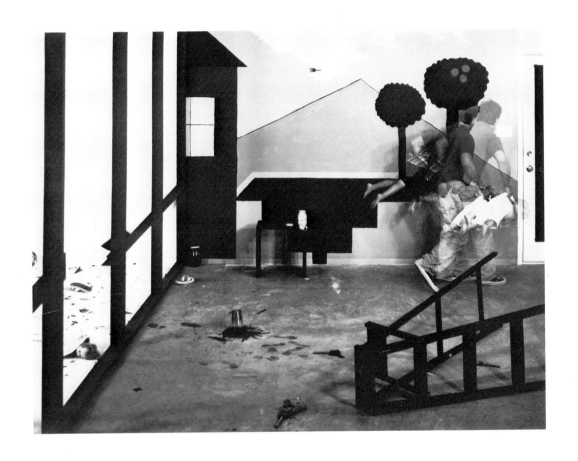

110.
Domestic Drama #6. 1982
Cibachrome print, 40 x 50″
1/15
Collection of the artist; courtesy Delahunty
Gallery, Dallas and New York

Exhibition 83/4

5,000 copies of this catalogue, designed by Malcolm Grear Designers and typeset by Craftsman Type Inc., have been printed by Eastern Press in September 1983 for the Trustees of The Solomon R. Guggenheim Foundation on the occasion of **New Perspectives in American Art: 1983 Exxon National Exhibition.**

Cover design courtesy Exxon Corporation

DATE DUE